Timetable

Be not afraid o' forbidden shadows
Jump right in, that's where it's shallow

No need to win,
You will not wallow

The tribunal awaits, the votes are in,
You passed each test, tried not to sin

Your friends are there to push you through
All of them know there's nothing more to do

Concepts live on, while the feelings linger,
And the message is clear

You were not born to carry either
Burden, nor Fear

Your friends are there to push you through
The reservation is set, at a bountiful table

Just for you!

A Saint

I ain't no saint, I've lived a bit

You were a sleaze now you're a saint

I smell your taint, it's on your upper-lip.

The circumstances unfolded, I lost my footing

Things got out of hand, and must have loosened my grip.

I was asleep, I was so weak.

Trapped within myself,

This hill's too steep.

Never yield, grab your pole,

The sacrifices bring along all of the thrills.

Those whom you fight against, they know not their toll.

Swim with the wind. Breathe in the cedar pulp.

Contemplate the rhythm of the waves,

Laugh with the wise old crows.

Equality will preside, beauty arrives,

Assurance for the smug will collide.

Choose to present your preeminent side,

Soar above with authentic pride.

The National

I prefer Canada, that's just my take.

With the majestic rivers flown from endless clear lakes.

Tecumseh took his stand to punctuate this precious land.

The beginning wasn't pretty, the blood ran like thick tar.

First nation's flesh stuck to snowy arrows, they were made to pay.

To proceed in these greed-riddled times, the brave Raven communities valiantly thwart the solicitude, by the men who are White.

Cherish to the ultimate degree, that we live in a vast paradise, stretched two oceans wide.
Put away your guns, take up an intense glare, mount that lithe horse.

Drink the sweet syrup of a tree. Keep our hearts: growing, glowing, strong, and free.

Mansbridge, Munro, Atwood, Berton, Mowat, the Don Cherry, Gretzky, Boyden, Cohen, Lightfoot, Young, Mitchell, Suzuki, Flora MacDonald,

and don't forget, Rex Murphy.

So many more know their score where pucks reign supreme.
Doubt never the protection of Her Majesty's perfection.

Welcome those new to our shores for theirs' were previously our grandparent's dreams.

I'm sorry, truly sorry, it's just a polite way to say excuse me, while expressing a blessing to you.

Now comes a troublesome age of industry's great demise.
I prefer this country, so rugged, rich, clean, and spacious.

This microcosm will continue to breed off the grid; for it knows steadfast the answers to which us humans are not privy.

We Canadians will survive. These southern neighbours cannot divide.

A refined sense of higher conscience; will turn out leaders of intellectual propensity.

We are on guard for thee.

Enemies can be friends, we will be your honour, and your guide.

I'm national, so very national, poised, amidst dignity.

Ode to Spring

Every single creature stirring, even a mouse

And on and on, flutters of gentle winds play sweet music in my ears.

Our lilacs get busy to sprinkle fragrances, that propose innocence.

The surface of the ocean refracts in alignment; such idiosyncratic distance between each wave.

Yes, Mother Nature is in full-swing, she's bustling, dancing, and springing in her steps.

She wakes up so very early, only to end the day in full cheer.

The bald eagle screeches so loud, when the crows circle round making such a fuss.

Do the crows really think they can distract this stalwart defense?

We humans can use comedy to wipe away the pain.

Tears running down the cheeks, cleanse like a day of fresh spring rain.

The Higher Road

Step up to this lofty embankment, take off your cumbrous load.

The spirits that surround us, make us act clean.

You can't be tough, while being rough.

The monster needs his screen.

We turned to hope at the end of the rope.

For great reasons, for hope presents alternatives.

Surrender to what this means, it may not even be outright what it seems.

The greatest debates are against the tides.

The twists, and the turns make one realize.

There are ways one tiny inkling can gather with much speed to take us down.

We can't hang on, call on the strong thrust of the soul's guts; our insides.

When the wider panorama swiftly goes out of focus, it's up to you to shift.

No outside distractions, no obvious screeching noises can claim full liability.

Even the tectonic plates are moveable, serenity does not meticulously rest.

Serenity made a serious date with eternity, this is one fact that all can attest.

Brothers

Wag your tail, mark your spot.

Grab your wits, drive a truck, buy your beer, and have your way.

When I told you I would always be here, I was speaking with veracity.

My truth was not a decision I needed to ponder.

You may wander until you find what may have always been at your fingertips.

It's never the time to mourn your lines, just remember, it's a race you may never finish.

Beat your chests, and thump your drum.

The maxim stands that I will try so very hard not to judge.

But I command that for you to follow, and I to lead.

There's nothing that will build a wall to separate us.

I heard your first words, and will savour your last.

I share your future, blood, genes, and your past.

You understand the code of thine brother, we certainly take care of one another!

Meet the Neo-Conservatives

Have you met, them? They're on vacation, but I'm sure you might.

They're on a sinking ship, there's only so much room left.

The elites are casting off their very own drones.

They have so much money, but the budget sure is tight.

The starched straight suits are well tailored, but the skirt is just right

That hair is so blah, but the boots were flown in from Russia.

Her skin's so thin, translucent, and white.

When she slips into her lair underneath her breath she hisses, and her body slithers.

The bourgeoisie of the province put the party firm in place, and made real their plight.

I mean really why should we be forced to bend down low for sheer simple minded justice?

Now when BC Medical sends you a bill you call a provincial office, and you've reached a call center in Nigeria.

The offices are shut down, there's cobwebs in the air. The contracted workers spit out their ill advice.

The civil servants that remain heard a mention, they buggered with your lives, you have exactly zero pension.

The ads keep pumping out hollow messages morning, night, and day. It is imperative to put a pipe in

to carry dirty oil through pristine rivers, and lakes.

At the forum they said, "Hey, oil spills create jobs!" "Never mind about earthquakes!"

Calgary had a monumental flood, but that's no sweat, no big deal.

We look to our first peoples though they were robbed by those who burrowed holes right through their souls.

BC first nations must not disperse, band together on the line between survival, and fate.

Against the ones who languish in their boardrooms on weekly budget slash night.

Neo-cons pick the pockets of the working poor, and use the unemployed for their ivory.

"There's a part-time job for you, and guess what minimum wage is the same as way back in 1991. See how we've run?"

Were the neo-conservatives and we know what we've done.

Hole Hoe

I'm left here to fill it up. You had your say, stamped your feet, and slammed the door.

Glimmers repeat in my mind, I close my eyes to see you.

You scream. My palms are sweaty, sticky, and hot.

My consciousness drops. Remember, being graceful isn't being meek.

You hang up the phone with agile speed. It was a pleasure for you, I guess.

That pierced my third-eye. The cloud followed me, the ghosts haunted me!

The ghosts drilled a hole, a deep dark hole. I was never given a chance to explain.

It is such a sham you knew your path. What a brilliant conception.

It was never that you should naught. This hole blew right through, radiating hot.

The gloves are off, just where would I be without a gaping wound?

Onward with disregard of angst, and consummate assurance.

They all say, you did your best. That certainly wasn't your best.

Finer thoughts trudge through the rot you had never even seen.

Violent candor spills on to the fire, just like kerosene.

A thunderous roar of words thrash into the air, trapped by their own recognizance.

You will never again be still. The magnitude of thoughts linger on unto eternity.

Shudder in the gloom that ensues. Precede into scornful dissonance.

Slowly ramble down basked by a fluorescent vivaciousness.

You have a choice not for lack, what an absurdity!

Bubble

There is another place, there is a world outside.

It's a game beyond sweet compromise.

Tidal waves roar in to take whatever they may want.

But, for you! You are not a wall flower.

They say you can do it. They know they can surmise.

You are special, so exceptional.

Your vision includes your heart underneath a clear sky.

Get this all down, there's an urgency to address.

Don't wait for that call, answer that bell, run with that ball!

The gales of change seem somehow familiar.

Embrace your faults, take a rest. Map out your way.

Kindness heals, hatred burns.

You whispered carry on as much that is regular.

You are special, so exceptional, you can do this!

Rich and Furious

Here I am, searching frantically for the emergency exit.

It's exactly two doors down from hell, the location is supreme.

Your phoney rhetoric mimics the sound of a babbling brook.

The froth around your mouth is the soot residual of your soul.

Like the sound of nails scraping on a chalk board your presence makes the hair stand up on my back.

All your friends are off-centre, sensibilities are askew.

It stems from a recycled vibe intention, that falls in the wrong dimension.

It's really nothing new.

I've digested some big books, I've fervently coloured outside the lines.

I've discovered some perfect principles worthy of your honour.

Wind down with satisfied serenity, this world is hectic.

Don't block that love that flows so freely. Take a sharper focus with the divine chorus.

I'm sure to fit in, leave them holding on to that big grin.

Fate unfolds this opportunity to show them what I'm made of.

There are no lonely spaces, the place is full of familiar faces.

A fascinated realization, holding your hands, I'll gracefully slip on to the other side.

Your Burden

I've worked so very hard to be your burden.

In many instances you blew through my energy.

The time was yours. I gave it to you. I glowed for your wretched love.

How I pondered every nuance for when we were together searching for some comfort.

With brazen intent, you knew so much of what you had done, it was all meticulously rehearsed.

You are so resilient, much worse in person.

I say you have the power to achieve your better self.

Bound, and leap, get rid of your cane.

Never get flustered, or tired, grow accustomed to the discomfort.

One must embark upon another journey, this one got old.

We all beheld your magnificence, you simply paused, and breathed in my innocence.

There was a tap, a gentle nudge upon my arm.

You gave unsolicited advice, and used your charm.

You tell all those who will hear they are a burden. All listen so intently, don't question their worth.

Unconditional love is what occurs at birth. Limitless patience is not unseemly, however strenuous.

Laboured tasks bring about the greatest gifts.

None to be told they are a burden, for it draws the inward down to your dull level.

What a disgrace. Prohibit your own advice.

Stalwart Angel Dove

My stalwart angel dove, how can I thank you for your sweet love?

We two are far, but ever so near.

There are some profound things my sensibilities can't handle. I can not control my fear.

You quelled my busy analytic thoughts, and said all will be well, all will be clear.

It's then that I flashback to 1973; with you lying on the hospital bed, your head all bandaged, me as a

little girl crying,

you telling me, "I'm okay!"

So many decades later, I stayed alive by the sound of your voice.

Your reason, your legacy has told me that sometimes, were not given a choice.

Here I am, all is well, I am actually fine.

There you lie, with your pain, in your bed; yet you led me through.

They sure don't make them like you, for there will never be, any one else made that is such a sweet

stalwart angel

dove!

The Last

Look up into the sky, the empty spaces are teeming with activity

Our lavish nurturing instincts are weighted.

Ignored are what can be gained, to relax, to sit, and to permit the silence.

The bitterness multiplies, in keeping with cohesiveness one goes into insanity.

The flesh, the mind, and the soul supine.

The extraction of love disbursed assessments, and opened a huge window to corruption.

Forces of hope failed to build fences to retain the unending atrocities.

Corporate agents who preached reciprocity lied.

And the paralysis slowly strangles. We reclined, and we gave a smile.

The passion for luxuriousness worked deftly, undiscerning decisions dried like cement.

We've tapped, scraped, cut, and raped. Production goes beyond the needs.

Can we contribute, redeem or cast off the grime?

Capriciousness has been extreme. It was not meant to last.

Whiteness could be seen through stark blackness. Purity was but a flash.

We held on strong to determinate ideals. There are no slow lanes on Busy Street.

At long last, this is the last, the very last.

In This World

Be utterly cautious about how you feel in this world.

We don't have power, we now have shields. Anger has slowly turned to rage.

One never hears about fear, for decades now, the word on the street is terror.

No more mundane is the report about the weather; storms and systems have proper names.

We must slow down, turn all of this around. Problem-solve with incisiveness.

Applicable for all that matters, love is benevolent, charitable, and propitious.

We never tire of dreaming in our surging minds, with voluminous pliability.

However daunting, good things only happen to those who are proactive!!!

Peel off the disinterest, make a significant contribution.

Concede to disagreement, wave your flag in amusement.

Passivity is called for in many situations, where half-witted battles will never be won.

The malignant spirit is a phantom, only but a hallow process of instinct.

You were deeply affected by someone's dread, and couldn't make it properly out of your bed.

Erroneous circumstances occur every single day, most are in fact those that are super-eminent.

There are copious things you can not construct, all belong to that restrained dominion.

There exists a smiling man of high standing, who goes around hugging the impaired, and the meager.

He is cautiously like the man who sang so eloquently, for his generation, about all you need.

The billions of us yearn for a higher temperament, it clearly exists in full.

There is only one language that concerns our intercourse. We can speak it, this we know.

Her Claim

She had a keen eye for the guy who pulled down the coin.

The army of hipsters were quick to point out her gold digger's nose with exacerbated shame.

Something she called love was besmirched with a hunger for gold.

Obviously she strode upon the lowest ground naturally meant for higher means.

How could anyone righteously place blame upon her claim?

A woman goes about seeing the wizard only after whiffing, and puffing.

Societal constraints were a mere figment compared to her condescending claims.

I did everything, I planned everything, you are nothing were it not for me!

She continuously makes a ruckus, and it wears you thin, until you must give in.

Whoever may block her wake will throw down their swords for pity's sake.

The woman is not a lady, no way, she is a snake.

That Alpha-She viper sheds her skin, she has no concept of fair compensation.

It was written by law the precise measure of her monetary stake.

And the years they multiply, revealing that her plans were lousy

with execution.

That wasn't love, no instead that was enterprise.

The multitudinous possessions form another contextual space, so far away from the deep sad lines of her face.

Therein lies the tragedy steadily unfolding.

Metaphors of Infatuation

So they conducted themselves like a disease, but no just any disease, one analogous to a direct descendent of the plague.

The pallor of his skin delineated with pleasurable empiricism.

Everything seems wonderfully coloured in your joyful spectrum.

Judgment is heedless of misconceptions. Just observe, don't hold on, opt out instead.
The butterfly smashed right into my semblance.

The metaphors they came to life. I encountered "Q", a phaser, and 'Captain Jane-way' all in the same place.

The crowd heaved on to your shoulders, and mine their grievances.
Your eyes they danced, they shone with luster. Your airy conversation it complimented the dreary scene.

You offered me delight through the foggy-haze.

Being around you illuminates my brain.

You're a striking, laughing, sweet melody.
You dissipate the creepy malignancies.

Every cell in my body tingles in unison with my internal drum.
Just look at what you have done.

The tenderness amidst cruel circumstance drifts by in a white fluffy cloud.
Seeping into my intuition a momentous propensity.
Every minute with you exceeds the last, and likely so will the rest.

Yes, this is pure frivolous enchantment, the only kind I'm sure such as this, there can be.

Super T and T Tornado

It can actually be real, it swirls around the infectious lively energy.

Like trying to separate a scientist from his beliefs.

The wonder strikes, it would certainly be impossible to quantify the strength it gives.

It is a fiery, bouncy, burst of joy; truly the epitome of fun.

I laughed for two days after, at a shared thought.

I missed it well, I know it's spell, my super tornado friend.

There is no way to go but up, forget about what made us sad.

There may be no such loss, so much there is to gain, when you, my friend, are in my presence.

There has never been one even close to bringing laughter to me through what may simply be mundane.

I exercised to my surprise the vital diversion in my brain.

Yes, I made blunders, I owned them well.
Our lives will not forget, and may nothing put asunder,

The wit, the dialogue that we may long share.
It may make you smile to know just how much my soul cares.

Each time we communicate, heed my words with comfort.

You may roam, you may run, you may cry, but may you know,
you have a friend
who's time will in no way dry!

Incarnate Amity

Ready, set, forward, go!

Billowing assaults, a measured comfort, a swinging, laughing heart.

Trembling fingers, cold feet, and a rush of wind.

A haphazard embrace, smoky mirrors, with a love recessed.

Just how much can really transpire in one exponent of time?

With precision, the moon looms ever in her hiatus. Many eyes dart around entwined at each juncture.

Tarnished soil, snuffed out in the onyx witching hours.

Yes, you love me. No, you're not in love with me. That is where you act with affected piety.

Well, it does not stand. You are not a pushover for anything.

Love is an affliction, put away between some pages. It's a phantom, a fable, made up to put a name to some bizarre behaviours.

Then I have exhausted every possibility. I was rooked, held down, it was painstakingly out of reach.

So now, let us be honest. Come on, let us be real, bring on the torment!

It was there. No, now it's over here. Nope, it went over there, you see? Yes, there it is, pointless, rash, simpleminded, however elusive, I think it's called: happiness.

Put a stop to those uneasy musings, for they will runaway.

This is exactly what you told yourself, what you chose. All along this is what that beautiful imagination spit out!

Slap some cold water on it, tweak it, and ease into what you truly envision.

There he is! Yes, that's him! That's his face. He sees you, his arms are around you.

You know this, you feel this. Make this one with bravado, with frequency.

I Enter

He definitely knows what will come with grandma's regrets.

It is a certain match, and so it may go, that indeed they put down one hell of a show!

Look at that man with renewed wonder, he dances, he runs, wiggles his butt to the crowd which is in the hundreds of thousands.

His cheeks, they are coarse. His voice, well it is hoarse. It has to be, Mick Jagger.

And we roll, yes we're true to that Stone, who must kick at the air!

Practice, get it just right, yes, the hands are floppy, that's his stare!

We groped, begged, and clenched just to reach that moment.

At times, our sins reached a fever-pitch. Yes, we pray for a rich benevolence.

So to whom to we offer praise? There is such an array; a mighty huge selection.

Yet, we're enshrined with a life off-side.

It's a knock-out. We were winded. Amidst the peaks, the valleys, the crumbling sidewalks, and the grungy alleys.

Democracy's carpet got rolled-up, and the bullet-holed streets sprung out of the shadows.

We presume a frenetic pace. Joy became something else altogether.

So, the hallucinatory moolah keeps on printing, but from the squinting, our eyes grow weary.

Yes, that old Hazel, she just ain't what she used to be.

Like a pimp, we strut, though an unwavering celestial sea surrounds us.

How do I enter? Just what has driven us toward higher consciousness?

There's an entitlement you see, one that governs all of humanity.

This invoice is so long overdue, leadership makes a place for equanimity.

Within this collective, I enter through the exit with a particular yearning to fix it.

Desolation

A man's demeanor makes one notice just how pieces of a hardened series of circumstances had been perpetrated without clout.

He has the wherewithal to spurn an aroused amount of doubt.

She, on the other hand, is frozen, closed-off, stiff, and is bound with steely reservations.

The woman swallows her breaths instead.

What drives us? How is it that motivation ignores reality?

An ominous sign marks the spot where the heinous crimes take place.

Who lit a fire with coals that smouldered on? The charred remains of life are as silent as the dawn.

The suite is ready, the guests are firmly placed. You modified the list, to the preclusion of higher tastes.

Ordinary trappings become contextually blurred. Outstanding reviews are forcibly heard.

Mountainous echoes, clicking quick steps, trickling fountains, hollow knocks on wood.

The party ran out of ale, in blood there was a trail. The erroneous occurrence of one poignant wisp of laughter, while apologies are intercepted. Resentments expand like foam.

Well rehearsed cliches are demanded by the press, they need a hook. *Au naturel* doesn't sell.

Quick, put up the skyscrapers!

Tell everyone exactly what they want to hear.

The truth, whatever that was, is out there, well were not too sure, it's not very clear.

Repair, revise, revamp, reboot. Be discreet! Clean it up! Put some oomph behind it!

Thwart the unacceptable. Conflicts go against the appropriate. Resolve, finish it off, create a better method.

The starving masses don't even want to chew your boiled wool.

Alone, but not lonely take heed that the road ahead is: crooked, craggy, edgy, and curved.

The Gain

There's a devolution in the works; it's so very uncomfortable
being close to people who casually keep guns in
night table drawers.

Scared, oh so petrified, that the adrenaline made the young man
come undone.

A seething feeling crept up with rapidity. Try never to be the
ones defined by someone whose point of

view has sordid potential, however hidden motives may seem.

They signed a contract in a metaphysical sense. In afterthought, it
wasn't a fair deal.

One had lost, and one had gained, what the other had been
sanctioned to steal.

The broken wheel had already spun, the gamble was ever-risky.

No quantity was placed for what the bid was reputed to be.

The scene was hushed, the particles of dust flew like snow viewed
through the sun's rays.

This flash of time trickled by very slowly.

His pupils dialed up, and with decisive synchronization, they
dialed down low.

More action had occurred in that millisecond, than had happened
in an entire week.

So many lives are linked together by one such strange horrific
split decision triggered by mysterious
cognitions.

The source got pulled down by a cryptic inner voice. One tiny tremendous ideal.

Copious humans observe from behind the glass 24 hours a day.

Innumerable losses, hate is softened to the point that it is camouflaged.

Stubborn Relevance

Put up your dukes! Now, make it snappy!

Take the fall. Play cat, and mouse. Go without.

Don't let me hear a peep out of you. Those are a dime a dozen.

And finally, there's that blessing in disguise.

That fool and his money are soon departed. One house divided can not stand.

My pet leopard doesn't change his spots. To convince her was a piece of cake.

We're all in the same boat you see. If you lose it, that'll cost you an arm and a leg!

She certainly was the apple of his eye. But his mother had her own ax to grind.

They continuously go back to the drawing board. She birthed a baker's dozen.

Never bite off more than you can chew. Blood is thicker than water.

Brake a leg! Buy a lemon! You crack me up!

Come hell or high water, try not to cry over spilled milk.

Never cry wolf. Remember, curiosity killed the cat.

You're a dead ringer for her. That was a doozey. They drive us up a wall my friends!

They grate on our nerves! But they are phrases passed on from generations.

They're cultural icons from another place, and another time, stuck in our consciousness of by-gone dreams.

Yes, these are just some of the multitudinous idioms that just wont give up, however annoying, they wont leave!

The Young and the Defective

Do I hear a rattling coming from your brain? You, yes you little one, with legendary business acumen.

What is that? Is that the ringing bell of your conscience?

With triumphant pretense she says my husband is the last person I want to hurt, but I must do this anyway. I am scoring some big points.

Your jealousy is so unbecoming, but I'll adjust, I'll get used to it.

We'll stop the bickering and we'll form a team. Damn, my mitt is ready for your foul ball.

You gave me a chance even after I ripped your life to shreds. It's my turn to out-happy you!

I will defend our home to the death. It is a time for hope and optimism.

We're a brand, although we don't have the skill-set, or talent to make it to the pro levels.

There are no demands, no weights, and no lies. We are living with our shells at our sides.

Disastrous outcomes clash with fate. It's all about having to live with the results.

Though I trust you with my life, our brothers and sisters are murderers.

This is not a life half-led; I've thought about this just enough.

Be blessed, and don't obsess about the people who have failed you.

You've always made it through things that would have crushed more than a few.

It's not my call, I didn't set out to pass out punishments.

We've achieved one prodigious buzz throughout this adventure.

So even Jesus fell down, and broke his crown, and the devil came tumbling after.

Please don't go backwards and blame yourselves.

The glory is yours if you will allow.

Powerful

He says to be cool you must have the accoutrements in plain sight.

Keep the raucous, romping fun at bay.

Be the definition of tightly wound. Don't let them see that unsound humanity, keep it veiled.

Emotions just below the surface reveal a vulgar side. Your natural impulses are scolded.

A brazen phrase in condescending tones are all that are permitted.

He got the chisel out, and wore them down for days.

For all of those who violate the code of stoicism will be reminded time, and again of your base transgressions.

Take your prescriptions however difficult they are to dispose.

All those around him abide by his sinewy policies.

For every resistant attempt, the chastisements make them ill at ease.

The public humiliations magnify. Authoritarianism is without question.

Feelings of hurt, fear, and suffocation all apply.

There were no reprieves, they were all forced to let the drunken monkey take over the steering wheel.

Catastrophes

Pulled out of the wreckage, the mirrored

reflection holds a revelation of epic distortions.

The floods, the torrential winds, both stirred up filthy debris.

A princess could not sleep, she made her decree.

The proclamation is that you get old, and get very tired all day long.

Never ones to learn a lesson, we reminisce about the daily grind.

Visions waver much like energies. You begin to believe in conditions that merely assume to be.

Young expressions are limited, but age induces a whole new meaning to obstructions.

Why is it so easy to ruin a good thing?

It's a compulsion to keep that finger off of the trigger.

Balance out the intrinsic eccentricity.

She screwed up her face to manifest her disgrace.

And so it goes, you truly bore us. What would have kept that craving at bay?

Don't pore over the evidence.

Keep some things sacred.

Perpetually on the lookout. Simply blown away by your calamity.

Falling

It was most definitely a plumb assignment. The wind, rain, sun, moon, stars – all in freakishly cohesive alignment.

A wedding of souls pledging their undying complicity speaking of truth, love, and trust. Such a radiant pallet that would make a noble person swoon.

The undulating grass moved with the steady beating of their hearts.

The eyes catch a field of towering daisies whispering in groups like busy children. A happy unison.

Pleasurable sensations surface with the intense energy coming from the focus of a wondrous one year old's hazel eyes.

Then you notice what goes on all around at the same time like watching Buddhist monks sitting cross-legged on white marble floors.

Twenty one day camp children jumping into a pool.

A typewriter clinking, and clunking, in a brightly lit turn-of-the-century office. The smell of an old oak desk.

A group of mallards swimming across a pond. A cedar sauna after skiing all day long.

A fresh rejuvenating eight hour sleep. Two kitty cats purring loudly with monumental joy upon each shoulder.

A sparkly clean sanitized bathroom. A teenaged couple holding hands while walking through the park.

A young man helping an elderly man across the street. The very first taste of strawberry ice cream.

A friend to hug you, and tell you it's going to be alright. The sound of the gentle rain.

The feeling of being dignified when taking the moral high road. A giggle fit, and one wide smile.

Climbing the ladder of success in any form, by any means.

The very first breath, the very first cry, and that twinkle in your eye when it's going to stay.

Then you become aware that objects are more in focus, all that you struggled with is wiped-out in one single swoop.

It's a mortal glimpse into eternity. Everything is basked in an angelic glow.

It's as if you were perpetually prepared to be ravished, and wonder just why didn't I notice this all before?

Flaws

You're so wonderfully, spectacularly flawed, we are not sorry to admit.

That's just so refined to not complain when the truth must be spoken.

There's a correct way to present bad news judiciously, with reflective calm, and patience.

Pretensions can swiftly destroy a good mood.

One does not expect to have to complete every thought, every movement answered exactly as one can conceive.

There exist as many answers as there are questions.

The toughest conversations are those that occur through long introspection.

Confusions will ultimately persist in any, and every situation.

And love is like the wind, trickling, blowing, gushing, and flowing.

Love is the divine cure, and the divine medicine.

The ego is evermore greedy, and needy. The natural listener takes it all in ever vigilant for every side.

Antagonism likes the grudge so desperate to control every single nuance.

Do what you should, be brave in the face of flaws.

After all the pushing, the tugging, the running, and the slugging, sweetness brings release.

Send away the clowns, send in the people who detect respect.
Politeness pulls everyone further along.

There are appropriate times, appropriate places to reveal ugly, voracious, grievances.

The tensions, and the shells mount. There will inevitably be legions of those who will tell you what is

wrong. They will be the ones preaching about what they know to be right.

So though they may consistently criticize, be not their martyr. There are minutes, and hours that you may strip off your armor.

They want to call you out, and they wont stop, for they will never know.

The key to longevity is not to give in, strip down, or hand in the reins.

For the greater good, apologize for any construed intentions, and gallantly abide!

Depravity

Wake up! You must have dozed off! Get up, follow me into the jungle.

Look back, look ahead, keep your eyes peeled – your peripherals on full-blast!

Trust me, you will need all of your heightened senses.

The light within you must be hidden, or else you'll be detected, they'll find out for sure.

If you are exposed they will mistaken your integral strengths, for weaknesses.

After all, the smell of compromise is so sweet.

Darkness envelopes, it swallows you up whole. All is desolate when hate takes its' strangle hold.

Each day hereafter you'll grapple for something to quench your thirst, satisfy your hunger, or dull your pain.

The answer is a resounding "no" my friend, there is no remedy in the land of depravity. This is a place where the water is not warm, no it's scalding instead.

On the same token, the wind isn't a cool gentle breeze; it is one with gale force intensity, that burns the extremities.

The music playing isn't just loud, it punctures the ear drums. There are no crowds, just mobs.

People need not weep, they sob. Love is replaced by jealousy.

There are no washrooms, just outhouses. The lawn has disappeared in a pile of rubbish.

They've constructed a barbed wire fence to keep the working classes out.

If you scream, you wont be heard. Don't stroll, run!

Not one single particle will be without its price.

Think long and hard, back to a time long since gone, and remember to keep the most imperative activities in close proximity.

Forsake all things that fade, extract your wits with the passage of time.

Creativity

Creativity audaciously grows, pushes, grinds and sways.

The monolithic sameness blurs into a battle ship hue of gray.

Minds get progressively bolder, the features sharper.

The heart becomes larger, yet weaker.

The character runs deeper.

The memory lusts for focus, as the skin loosens to manifest the time.

A day of tribute to oneself runs short. Daily tasks are pointless.

You remembered to save for the rain. Seized are those moments of teaching. The quality of relations increase.

Aspects of care, and nurturing reach a pinnacle – one craggy, jagged peak.

Imperfections are the utmost precious to behold. A glorious crown of contentment in celebration not to suffer under the guidance of fools.

A sensation of life taken kindly in the role of mentor.

A compelling desire to speak, while with respect, to be heard.

To be loved utterly in an authentic gentle manner knowing insights were successfully imparted.

To be taken with a soft impartiality. You walk with authority, dignity, and a sparkling humour.

Thriving paradoxes are so deliciously observed, not to wince at

the mere thought of adversity.

Pure resistance to the need to pay close attention to the detractors.

There's a devil's-advocate, or cynic, ready to admonish in every crevice.

Knowledge comes to those who participate fully to relish each mistake.

Don't partner with a truly selfish individual who does not listen to your core.

Users move on to the next one when your well runs dry. The role of prey gets old very swift.

Experiments are valuable taken on with unending curiosities.

Wisdom is a medal to strive for, a badge of honour, that does not come cheap.

Beautification

She was not aware of her affectation. All of the commendable Graces had assembled to erect the delicate planes of that face.

A blanket covered humanity's sensibilities to awaken a latent desire to be in her presence, the one endowed suchlike a freak of natural synchronicity.

With lackadaisical charm the royalty of her form entered into any space.
Despite all noisy repercussions, she only wished to be like all others; insignificantly placed.

Twofold vanities were haplessly thrust into the foreground. Respectively in uncomfortable relation.
Mad skills of diplomacy are urgent. Necessitating the need to try much harder than the rest.

Equilibrium caught without exception all breaths, squeezed, enjoyed, and wrought, as if sparingly supplied.

Prying eyes averted, an obvious separateness that was understood, but never openly shared.
No peers did surround.

Outrage met anguish in total silence. Energies completely spent. Heads in stances abashed. A heart like a candle lit, but not at all burned.

A disruptive inner turmoil engorged malcontent. Inevitably a tumor took shape.
Veins overworked under pressure gave off a bitter stew of taste.

Alas, in the midnight hour the rescue team dispersed with unwieldy haste to quell distress.

Compounded severity burst a sheath of appreciation, which unduly exists.

For those with clear intent of harm, may they wallow in the darkness of their own creation.
A suitable dungeon to quiver in for the community of lost disgraced souls.

The subtle reality is malleable, a true vision to test.
True beauty, whether or not visible, to the naked eye is beyond disdain.

Fly into the Face of Facts

When privacy prevails it is now the time to trace that which lies beyond what is real.

My dissertation has long been received by intellects who discuss it with zeal – every word is analyzed.

A house sits on the shores of the ocean, the mountains dot the skyline.

A garden of flowers, vegetables, and fruit trees surround.

Every morning begins with a walk in pleasure along winding familiar trails.

A boat comes by weekly for a dabble into the city.

Food is an exploration, a vacation of sensory overload.

Sun salutations are a daily must. Music harmoniously floats about, and dancing is taken quite seriously.

A deep learning curve is met with every single day. A novel is opened, the contents are shared.

The exercises of love in constant verbal utterances sprinkled with much intercepted give, and take.

It is all tangible, the soul must say, "Yes." Whisper to the breeze, what you conceive.

Your dreams will suddenly dictate. So be it that there are billions of us.

The initiation of the process is but one flickering in the brain.

The concentration of power can not be surmounted by doubt.

Give up to the fight, the battle, the struggle, make way for other more important things.

Cling to right here, the dirt will gather right there, collectively in a powdery dust.

Take great comfort that the privacy of perception, will withstand tumultuous strains.

Sufferance

Decision-making at the executive levels pour money into what the top 1% see as the problem.

Who are these people in their ivory towers looking from on-high to the inner-city dwellers? Why do they get to throw money at causes only dear to themselves?

Let's give a sound voice to those who don't have one.

Ignored is the most burgeoning yet preventative one, childhood obesity over 30 years the numbers have tripled.

Indicative that children from poor families don't have the money needed to provide nutritional meals.

Healthy food choices are much too dear.

Sugary, salty drinks that are full of addictive properties, of course, are come by easily, and cheap.

So obese kids who see the reflection in the mirror, and they don't like what they see.

The sugary drinks they can't get enough of, have taken their toll on their entire mentality.

These repercussions will spread into their lives right into adulthood. Riddled by that voice inside.

All hail to the 90s! America administered billions of pills to children, millions of minions with ADHD.

Your brain isn't fully developed through energy drinks, you've had the equivalent of four cups of coffee.

You're a child with purple rings underneath your eyes, you can't

concentrate, the caregivers just can't surmise.

It just can't be that your ten year old was up all night drinking pop, and engaging only in the virtual world.

Suicide is a way out for the addict of twelve.

The money pours in to manufacturing the ills. Furthermore, research is lacking for those who rely on pharmaceutical interventions.

Misconceptions, misdiagnosed, for this world is host to the business strategists.

They've unleashed in mass quantities cheap products that will for decades come to signify chronic mental-health sufferers in an entire generation, but hush sweet science please be compliant.

Complacency is atrocious, the dialogue yet to be fully unleashed to bring forth solutions of unprecedented worth.

Democratization of the World

General Francisco Franco is dead, so then dramatic democratic processes were ripe to ensue.

Sweeping transitional proportions are mandatory.

Is the spirit of democracy a regime? Was it marching in judiciously, yet competitively? Are these the same things?

King Juan Carlos quietly held the key, to gently push his constitutional monarchy.

Are we now lost with modern authoritarian processes, who devote full time attention to merely crippling the opposition, without annihilating it? But no, they instead smile while choking them.

Now they flout the rule of law while maintaining a plausible veneer of order, and prosperity within their own borders.

Spain 1975, presented a peak transitional opportunity. Civil-war wounds were fresh, and democratic prosperity was ripe for the European community to open its borders to free-trade. Money was what all the fuss was for. It's a farce of human disregard, this economic reasoning.

But my has the context changed, with technologically charged protests. The world puts on a great show!

Resistance is deemed futile, where there is no division between Church, and State. Therefore, Draconian measures do indeed still exist.

Violence and human rights violations are prominent, just like they always have been. The protesters nearly invisible, where the crazed mantra is Islam.

The hot beds of violence are strategically placed where resources

are lacking; these tight-fisted luminaries staging skirmishes all
over the place, so unjust.

After all, with God on your side who can protest?

Spanish democratization model proved that the transition can
occur without a bloody revolution, nor civil war, and with a
window toward prosperity.

21st century tussles abound, the bottom people displaced together
with skimpy oil reserves, battle in the
name of Allah, thrust economically charged agendas on the table,
and that's all the fixings for one toxic brew, we have truly lost
control, with worldwide oligarchical forces askew.

Into the Modern Age

Not enough has been said of 'golden lotus' the status symbol of the manifestation of beauty.

Break her foot in childhood so that it will not grow more than three inches. Walk a long road.

Sex manuals during the Qing dynasty exposes the virtues of 48 ways to bind her feet.

So then the colonists make their way to Chinese soil. Marco Polo thinks how remarkable that the delicate flowers sit stationary working away all day long, hanging on every word their master says.

It's a pleasure buffet, amazing it seems that there are prostitutes to tend to every man's needs.

To bind their feet is a matter of course, purely esthetic, harmless to say the least.

It occurs in the 'well to do' as a badge of perfection.

All ladies would hobble on their feet in a sickly gait.

One thousand years passed before the religious zealots exposed this gender based violence.

Gender based violence is such a disgrace, yet it occurs on every continent, within every race.

Foot-binding spread like wild fire throughout every province in China, with trade routes growing, families scrambled to marry the women for socially upward mobility. Hey buddy there's no choice, it's a trade.

The facts they showed the true evidence. Most women with

bound feet were from the lower classes.

They had their place stationary, so that they could make clothes for everyone in the family to be the prime bread winners.

Consistent mores ended the barbaric practices of the dynastic dictators.

The missionaries arrived, they staged rallies intermittently.

The message was about Christianity, as it stands for human rights.

Women with bound feet would take to the stage their feet unbound. Celebrations of freedom transpired.

These beauty myths are still very real, women worldwide have so much more ground to gain.

We Westerners hide our curves, we open magazines where especially the adolescent girls who stare back at us, appear as though they haven't eaten in years.

So who is to interpret what is beautiful to behold, what needs to be said, what is acceptable?

Global Harm

The literature is front and centre, it's out there, all over the place.

The scientists who have made the subjects their lives are waving their arms, and jumping up, and down.

It's past due time to listen!

Don't worry about profits there are government incentives to cover cap policies on emissions, if you were prepared, you won't be left out.

The detractors bellow that with a track record of dire accidents, who wants to rely on nuclear reactors?
A new grid for wind energy also has consequences. The turbines are loud, they're making people sick.

It's time to speak for the beings on this planet who are without intrinsic rights, who cares for the creatures who are drowning, trying to swim across the breaks in the ice?

Corporations, small businesses, all must take heed to the plight, and step up to grab collective accountability.

The naysayers march on, desperate to argue their cases.

Evidence from billions of years show greenhouse emissions are part of the natural turn of events.

Yahoo, there will be green patches in some places where nothing used to grow. Absurd as it may be, imagine Hudson's Bay could be the new Caribbean.

Most big cities that are along the coastlines will have populations simply migrate, to higher ground.

Desalination plants will be popping up, wherever inland.

Overall it looks pretty grim, sitting in the prime power placement of world events sits China, and Brazil with track records so cumbersome in adherence to cap policies.

The conundrum is driven in most part by economics, when in fact, it is purely a scientific issue.

The scientists agree, and disagree, it's part of their natural inclinations.

This phenomenon gets mired for arguments sake, with politicized rhetoric, and images of apocalyptic outcomes.

The issue gets driven off the road by religion, and fear; to the detriment of getting things done.

To what degree do we raise the alarms? With scads of interest groups, and countries, it is plain to conclude this mind blowing issue, is at best convoluted.

Ewe

Spirituality finds expression in all cultures; it is a binding force, a moral compass.

Mawu of the Anlo-Ewe tribe is considered omnipotent, which defies form, so the artists dare not render

Mawu exists like the mists, frequencies of colour, sounds, and a wisp of wind. This is the emperor of all gods.

The elders then do gather to act as judiciaries to decide as to whether tribe members are worthy enough to worship Yewe, who's in charge of thunder.

High priests make sure adherence to certain moral actions are followed.

Members of the tribe are committed with utter devotion to dancing, drumming, and singing extravaganzas.

Ostracized punishments are enforced for individuals who do not seriously participate.

Mawu transcends conceptualization, but embodies a fierce rectitude without equal.

Ancestors live on multifariously, never to leave the sides of their kin.

What it must be like to thrive on living for being reflections of one another on this life's path.

Character is formed, reformed, and transformed.

Mawu is literally the one who does not kill: it is the bountiful, and the merciful.

The propensity prevails to garner meanings, by what it feels to be human.

By necessity, daily living is full of hardships, Ewe rely on the water, and the earth in a real sense.

Instinctual symbiotic relationships are the key to survival.

Divination is called upon when choices are not empirically ascertainable.

Corrective course of action is impossible, to logically be reached.

The divine world explains all that is beyond, that which can be easily explained.

Mere existence is a privileged harsh encampment.

World War Done

Like a fairy tale cliche the saying never will cease, that it was the war to end all others.

To fight for Mother England against the Kaiser, the young boys lined up to volunteer. Some cheeky underage kids fibbed their way in.

After all, the cause was a noble one, and there was the promise of adventurous heroics.

They were so very young, the fresh faces were not even at the stage to grow facial hair.

It was with panache, it was with great fanfare, that they made the boat trip to the old-world.

Slowly the realizations set in, they were sent there to stand up in a line, against a wall of gunfire.

Appalling conditions in the trenches: with the mud, the rats, and the dysentery, were hardly discussed thereafter.

Yet first hand accounts tell of keeping spirits high, and hope that has no bounds.

Millions died in amongst the filth, hardly the adventure their minds had perceived.

The soldiers were but part of one big experiment of chemical weapons, the poisonous gas came creeping in, even when the guns were silent.

Death was swift with machine guns, but with mustard gas, it was a different agonizingly slow choking that occurred, and into death's arms, they did so very agonizingly succumb.

Over 600 000 enlisted, and they walked along with their heavy uniforms, heavy artillery fire, stepping on to their brother's dead bodies.

The soldier boys gave it their all in 1917, the greatest victory of Vimy, such a pivotal right-of-passage in the development of national Canadian pride.

But in the final battle of Passchendaele we lost 60 000 in all; a triumph of high cost.

But young Canada became older very quickly, and when in 1922 Mackenzie King was called upon to provide troops in Turkey, he refused.

65 000 died on the fields, but of all the soldiers who returned in essence they never returned; for they traveled so far to step on to their brothers dead faces.

No, we will never forget, their stories will always need to be told, their young spirits had long ago wept, their hot young souls quickly became so run down, so cold.

Fertile Barrenness

Oh, but you should pour all of your sympathy upon us. We are the ones who adore your sympathy.

To be warmed, to be hugged, to be reassured, with your illuminating force of concentration.

Take me into the circle of life, sprinkle me with magic, take away my strife.

I'm a failure, I say it louder so that you may hear. I want you to tell me, "No you're not, my dear."

You said I was a genius, so bright, restore my better senses, make wrong, what I think is right.

I am the greatest meta-physician of this epoch of time, so prudent with the truth.

Upright, confident, diabolically incompetent.

Flash me those eyes that set my engines all aglow. Open the door, lead me thereafter.

Flash me that enduring brazen, sneaky, wondrous smile.

Where have we been? Where the heck are we going? It's absolutely obscene.

There's a twang, and a twitter of emotions, people looking down on me.

I'm needed all over the world, not just in this room.

It's one delicious fecundity, a sprig of life, having you in my arms, listening to you breathe.

I traced up, and down, all of your fingers with my own.

You gave me your time, I gave you a lifelong home.

Such conspicuous radiating loving integral thoughts, that stir what I'm made of within.

He infused all of that what besmirched him to give me, you see.

There was such a heavy tug at my heart, I suddenly wanted to tell him all.

I was awash in the spinning mass confusion of events. Wanted to be apart of something whatever it meant.

I don't want to hear what ever does it mean that word, that concept, limitation?

The Queen

Who doth dare walk in front of her eminence?

Known not as Elizabeth, or Liz, that is her majesty the Queen of England, the Queen of Canada too, she is at the end of that stuffy, rugged, golden blood-line.

Most definitely the last of her kind. There will not be another of similar semblance.

She has a so many opulent homes, all the caregivers, all the carriages, all the pomp, and circumstance.

Though known for her quiet presence, she owns every room she enters, her dubious wave, those forced smiles.
There's a swoon, a hush, a most perfectly orchestrated reverence, that reverberates admidst every move she makes.
She is noticed for her stale humility, yet she commands the greatest of respect.

Then on the other hand, there she is most at home with her silly stump-legged dogs, with her horses, on

her farms, in dowdy clothing she is at nature's command in her beloved old dilapidated moss covered

castle in the rugged terrain of Scotland.

In 1953, it was decreed that this young woman would take over this grotesque responsibility.

Elizabeth took very seriously over her charge, such that was bungled by her predecessors.

She stood with her voluminous crown, and scepter. She kept sacred her staid wedding vows.

Elizabeth had to keep that stiff upper lip, whilst all around her children did disappoint.

Hers' was an exalted position, one that only God could appoint. She knew she had to live up to her calling.

She reigns still crusty, cemented, lamented, and supreme. She's survived many years of disdain.

Every day she rises, wields that pen, not that sword, she lifts her cup of tea, she walks into her home

office, and signs the pertinent documents.

She is alone, she is far above the madding crowds, waving with her stiff, pristine white gloves.

I believe she understands the meaning of duty, the plight called boredom, but her image, however dull,

will burn in the minds of her subjects: a subtle comfort, a symbol of stability, in a whirlwind of

uncertainty long after when she finally decides it's time to leave the

enormity of the world scene where she reverberates long, long the dutiful Queen, ever after.

The Quintessential English Rose

The innocence you wore on your lips, your eyes, and not to mention your life-blood of such an azure hue, that supple heart proudly worn on your sleeves; I, amongst billions adored you for your sweet honesty.

Those tear drops falling from those eyes as deep, as the deepest blue seas, were helplessly so very public, but not one could look away from you.

All were mesmerized by your style, by your grace, that unique enduring warmth, by your stunning statuesque figure.
You need not to adorn yourself with the largest jewels, they were surpassed by your presence.

Oh no, you would never be deemed plain.

Just one glimpse from you, to the people of all ages, and they were putty in your hands.
I was one of many who melted by your vision.

You showed us your deepest tender insecurities, you bore the vicious burden of a love unrequited.

For all the dubious treatments from those close at hand, those far away, could feel your pulse.
You took on the role at such a tender age, like the sacrificial lamb to the slaughter, in a lead-lined cage.

You trusted those without decorum, of the nobility class, to be your family.
Like all young girls, you believed in the everlasting ideals of that higher love.

You turned victim into victor, to reach out beyond your royal boundaries, with ingenuity you exposed that ugly truth.

Painstakingly cleared your focus on your love for your children, the down-trodden, the ones with HIV, whom you hugged openly, despite your position, it was incontestable that they were accepted.

And though many years have gone by since you left us, so very young, vital, and with such sorrowful, regretful tragedy. We can not believe such a bright sparkling light has gone out.

We protest with too many unanswered questions, your face burns vividly on our world stage, upholding a vital position, there is a comfort that you were once among us.
We, us, all of us, will not obliterate from our minds what you brought to this world.

So like in '97 that Haley-Bop Comet a rare occurrence, blazing in the clear black night, you blazed upon the stage, and left a trail of bright flashing images.

The spontaneity of your graces linger into immortality. In viewing you on screen, your inner brilliance takes over, you brought superficiality some real depth, an inexplicable vivaciousness.

The mysterious powers that you were imbued with Diana dear, are still very much an essential part of the overall public consciousness, political imperatives, and humanitarian deeds.

There is no way we will let the perfect English rose wither.

Pills

He is someone's father, the oppressive inner dialogue is overworked, and over-played.

To pay attention to the smaller picture, the immediacy of each nuance, is a task that rips the mastermind.

Obsession is oppressive it supersedes all else, assails the senses.

Dialectics incline to be treacherous beings.

Hostilities control frame of reference, then one's entire demeanor is irreparably bent.

An emergence of something unwelcome in any social circle lords over like a tyrant.

There is nothing this strain of disease can be treated with, it is staunch with its denial.

It pays very well for the silence of all others who pay cash, it's street credibility is well won.

Authoritarian forces of nature answer pitilessly to it. A bulldozer gets crushed underneath its spell.

So the almighty takes a vacation even when he's on-call.

Neither words, nor actions, nor pure rumination, are anywhere near conception.

There is but one line of reasoning, drowning, bogged down with misunderstandings, warped intentions.

The lamentations are conducted in private, negligence is ignored.

Committed is this secret criminal activity on thine own self, to

which they are fallacious emotions.

This isn't a hoax, or a bit of information you gleaned from the internet.

Dreams can be illusive, improper, inaccurate, or unseemly.

Realities can be apocryphal, or fraudulent, it all depends on who you talk to.

What is it all about? It is like searching, reaching, stretching for the one thing unattainable.

Relief is imperceptible, you're going the wrong way.

The hired help is unreliable, thine own, attached to that which is unlatched.

Suspended Beliefs

How many decades have wandered by since speculative musings told the palpable tale.

No really, it happened so said my cousin's friend's boyfriend's, sister's, husband's aunt.

The brisk wind knocked out all senses that were acute in that minute.

Remarkable stirrings traded up for any thing better, one they daresay more complicated than the rest.

Perchance there may be a strain in diplomatic relations for they endeavored to be considered the best.

There's the pitch, development, exploration, experiments to prove our acumen.

There is a cloak over all of that dandruff, a staple in that stomach, the make-up to hide all those bumps.

So they qualified for the finals, they played in the champion round, regardless of the whispering controversies.

Not one could hear the whimpering weak links, one sweeping hand movement to make them quiver.

And the grudge was dishonest, it was a ruse to force our attentions else where.

The magicians hands fluttered, a slight of hand movement that had our eyes transfixed, followed, one never knew there was an intrinsic screening in the process.

The money pilferers have but one dimensional offerings for humanity, one dimensional skills.

Be egregious of that waste of intellectual skills, those who are the loudest amongst us are the least threatening, they slip up righteously, devoid of feeling.

The demeaning that the less talented thrust upon my person leave me unaffected.

Only those with composed dauntless, yet quiet, dispositions know the score.

Regardless, the psyche is bone weary under the influence.

They told you to use this to fill up the emptiness. It failed on so many levels.

Your stouthearted resonance suddenly kicks in to high gear. You are unabashed to make those exceptional blunders.

That plucky girl you long thought lost, now stares back at you in that mirror, your audacious self catches her breath from time to time.

Don't forget to make it clear you miss them more, your love is strong, enduring, and manifest.

The Thrill

Cut to the chase, right through the bullocks from the moment of contact.

A template used from time immemorial presented as trustworthy mentor.

The gaps were precluded, filled in, the results already drawn up, a seedy scheme.

One to give, one to lose, one to attempt, one to fail, one is invariably overruled.

See it as your obligation to all in this state, where the norm is disorderly conduct.

Repudiation of societal rhythm, it is truly a free-for-all.

Not every person deserves to be on the top of the pile.

Forever reminded that you should, you must, what you are not to do.

The eyes were tightly closed but they could see, far, wide, low, dark, deep, and wide.

Stereotypes spring from centuries of patterned behaviors, perhaps one will be more suitable than another.

No span of time washes away the grit, for everything kind you did, was done for a measurable, considerable insidious pretension.

It's difficult to wrap the mind around how the wheels did turn, step-by-step.

Squeeze every ounce of life out of all the others, make them pay

for your discontent.

I bailed on the entire circuitous, heavy, death-defying act.

An acknowledgment of a blatant refusal that your powerful suggestions would claim me.

The words would just escape me, there wouldn't be enough time to explain.

There is no reasoning with one who refuses to listen.

Unsolicited advice is never intercepted.

Once you're committed, your selfish preclusion have invariable repercussions.

Through your own omission, you will long live in the shadows you cast.

Blissful Resentments

Incurable stupidity will be unavoidable when forcibly tapped into the brain.

The disdain originated from the imprisonment of your assigned position.

You are what other people have long thought, what you should be.

It acts like a steep betrayal.

The plot is so drawn out, that you missed it's significance.

This is not what I had hoped, strange notions got the best of me.

Each one was immersed in governable wretchedness.

Why me?

Is it so very simple to embrace the beauty of melancholy?

The fool ignores the bad news.

So they told you not to hold those indignant accusations, see it my way.

And one found it laughable choose what you'll be better off without.

Defeat with luck instead of being defeated.

You kept it all under wraps with knowledge of the intelligent selection of that which is sacred.

Functionality, punctuality, intently listening, respectively, all are vital virtues.

Undertake the risks instead of endlessly researching the theories.

Cease using that brick wall as your captive audience.

Keep your scrutiny in a forward position, stop commenting on the ones at your side.

Give just so much value to drastic indifference.

Realizations that don't change stubborn, ill- fated convictions.

The Statement

Give in to that which is inexplicable, the soft landing strip.

The state of permanence from those gawking, leering, prying interested third parties.

Contra the discerning tasteful arrangements.

Those are apropos the connection via the persuasion of a tough-won fight.

Decline to comment at the behest of ones exposed to an experiment.

Use discretion irregardless of who's company you may find yourself in.

Exhort those repulsive exchanges to precisely lay the blame.

There is no us, one is not selfsame.

In the genre becomes a mood, above a classless intimate deflection.

It was a convenience, not predetermined in the least.

A singular impression gave a static thread to everything.

Those exquisite prerequisites were well endowed.

A paroxysm overcame all the precedent elements of the scene.

Disproportionate punishments are unleashed upon the unguarded.

On occasion, the rapture of efficacious formulation.

An air of odious recognizance envelopes the expressions in the voice, till it makes one wince.

There exists a multiplicity in every living thing.

Impeded by improper functionality instituted by the roles of the sexes.

Fret not about ignoble treatments.

Draw yourself together for hurt comes by not cleanly.

The joy of music may not diminish in the fading promises of surrender.

If Shakespeare Had Not Existed

Love, drama, duplicitous dealings, anger, honour, loyalty, fellowship, all notions alive, yet unseen.

Shakespeare's colloquy have for so long bore fruit for so much that humans can not begin to grapple.

The mysterious unknown William Shakespeare gave us fodder for who he was everlasting.

Forgiven are even the most reprehensible characters, for even Hamlet blesses Gertrude.

Beyond the class structure of his century, comes an acknowledgment that love defies all sensations.

Love is nobody's fool.

Divinity pales in comparison to the affinity of love.

And when families try to tear two young lovers in the throes of love apart, Shakespeare dared to let them die together instead.

He bore through the heart in ways never surpassed since, not close as we do in modern context.

The characterizations and motifs of Shakespeare's plays are fundamentally part of unremitting intellectual discourse. We marvel at what scrutiny is beholden.

Masculinity can be cruel, power becomes manic, brothers take arms against one another.

Kings turn into tyrants.

A common thread of violence, hallucinatory visions of the

conscience.

Shakespeare's clever use of symbols, prophecies, blood shed, and the shared experience of setting the mood with weather.

The poet stirs up the emotions of his audiences, and leaves them longing for more.

Shakespeare wrote so that all aspiring writers could endlessly have their say to share in their interpretations.

It is a wonder that we may find several aspects of ourselves in our lives in all of his works.

Without this wondrous being who left behind so much more to reveal each time we open one of his works, we would have no mirror, no relation to vibrant living art written during a time when communities were closer, much more face- to- face. Value without boundaries.

Shakespeare is our touch stone, our measurement of ourselves, in this exhausting human race.

Vancouver Island's First Nations

I don't think they understand that this is our territory.

It's time that they understand those men in white shirts, and black suits.

The cedars hold the authority, having been here looking down from high up above for time immemorial.

The Royal Museum holds the documents for the protection of our staid B.C. Douglas Firs.

Underhandedly written in English, and signed over by the tribes' leaders with an X.

For, English was not yet widely known. They represented a treaty of friendship not honoured.

The trees fell anyway.

Devastating impacts on livelihoods, the very life-blood of the first nations.

A reduction of resources, a reduction of government funding, have obscured the sources.

Rights to land so long occupied by the band, now must go before the courts.

Throw a light on the archives signed by an X to revive the claim to the forests.

The forest is where you live, thousands of years to grow, yet just one generation to destroy.

It goes beyond moral judgment, beyond what makes proper sense.

This is our medicine cabinet, and a place to be close to the sacred.

When you look after the forest, the forest looks after you. I brings you what you need.

Ancestors have given the love and understanding to perpetuate the caring.

Respect what they have, those who visit are in awe, and will respect what the land gives.

The raven, the eagle, the orcas, the deer, and all other creatures implore us.

We have long surpassed the state of environmental urgency.

Embroiled in battle with the government the First Nations are mobilized in

their vow to go forward, to protect, to stand up to be

proud, be free, and to live out their permanence: our nation's saving grace.

Words

Settle down in urbanization. Measure the competence of your disgraces.

Wasn't it you who told us that everything would work out?

What is it that Mother Nature wants? Is it wholesome, is it something that might be life changing?

They already did all that that was asked of them. The game was modified to make way for the player.

Stagnant approaches did not fit in with the budget, what I liked, what was uniform.

Warmth, vibrancy, delicate exchanges got the best of us.

Increased values meant that paradise existed in the nearest conveyance possible.

So that was the way we wanted to move. No constraints on our time.

The lion's share of the boast was in the fallacious achievements.

The mess is there. Dirt shows up indiscriminately, it doesn't disappear.

Believe in the pathway to openings. Let nothing put assumptions forefront.

The incessant chatter whispers misguided faith.

Worry not for what it takes to accept, however the steps are laboured.

Trending now the social phenomenon blitz.

So that we may see the challenges, for all of us who reveal what really is.

No cause is unexplored, have the machines made us clearly humans?

We are thus that are thankful to even be considered. We are entrusted to participate, to have jobs.

It is with reluctance that one does become expert.

There may not be enough time. Once you say them, they become live on screen, and in print.

Wisely chosen, with utter confidence that all will support.

Peculiarities

Pushing the boundaries to expose deliciously admonished public perceptions.

Caused are reactions to sights unseen, bringing out unseemly misconceptions.

Beyond modernity, poking fun at the contemporary landscapes.

Humility takes a back seat, to the seediness, the self-serving interactions with base morality.

Secret relations uncompromisingly severe, don't belong.

What now to be considered modernism somehow is clouded.

Very distinctive representations smack full of references of another era.

Push the buttons, click the screen, who is that staring back at us, but someone that was carefully

measured, hopefully, carefully crafted.

The cerebral cortex meticulously sifts through the thousands of subliminal messages.

Never mind that were told that the scientific research is inconclusive.

A truism persists that science is perpetually elusive.

Paranoid dreams may not be so elusive, they just try to make it seem that way.

It's a matter of checks, and balances. Garbage in, and garbage

out.

The mind can doubt all notions that are beyond words that are stuck, not free-flowing.

Love allows us to be grounded; it comes through congested confusing malignant forces.

The raven is the trickster that can morph into crystal clear formations.

If there is enough, then you know what it is you are taking through your heart centre.

You will not have to lie in order to join in; you belong.

There is plenty of room, it's not cramped.

Weary

An emotional state that one can not escape, that shows in your actions.

The eyes that don't say, "yes" they shift, and look all about with no particular focus.

Boredom is only a primary degree, a symptom of the sickness.

White has been yellowed by overuse, and neglect of care.

Stringy hair, matted, with permanent bed-head.

The feet drag across the pavement, the shoulders slumped, personal hygiene took a vacation.

Promises come out in hollow utterances. Trust is thus, unrecognizable.

Maintaining the garden that was overgrown with weeds.

They gave up on trying to be civil, caring, loving, or kind.

The worthiness is annihilated. No matter when, they see a gathering with you as opportunity.

A chance to flirt, a chance to behave out of the norm, knowing the depth of your tolerance.

Let them think that they have the upper-hand. You care just so little to protest.

All along they know what they can do to push the limits of your discretion.

If you thwart their behaviors they will wipe you off the map, and

you know you'll not see them again.

No loyalties on the other side, just for one, not for all.

It may build up for years, like an oppressive force, so hard to resist.

You can not come to expect the worst case scenario.

The trifling events of life convince, must thrust us into convictions.

It is a passageway, a virtual freeway, shifting under the pretext of elaborate subtlety.

Frighteningly deep-set not too slowly, nor agonizingly die.

Everyday

There are billions at-risk. Themselves at times looking back upon ill notions, if there be time.

It is their lot in life to strive, to kill or be killed, it may be so simplified.

So problematic is society, one is graded as to what degree to be exposed to condescension.

First world headaches don't amount to much. But the worst conditions exist in the first world.

Someone else over there is culpable, the reason this happens is in our own back yards.

It will be ignored as far as it can be, until all of the clever cover ups run dry.

Escalations, even those that are glaringly addressed, it's as though they are a bother.

Call in the military, they are beyond inspection, so above the rule of law.

A small time value against big time interest.

Right now, can be withstood, so we don't like that which bites us, throws us in discomfort.

Rats caught us in their ruts. Disputes, so they are flagrantly called, settled out of court.

They wave their pretty well manicured hands in disagreement.

No comment offered, threats still hushed, shut up, that is what we

don't want to hear.

All too often the quad copter drone peers into our 36 floor apartment window, a criminal harassment.

What are the limits to civil liberties, there are logistical legalities not to be overthrown.

An enormous greenish trail of light streaks through the night.

It could be that meteor shower that we told everyone about, oh well.

The rail company had a weak safety culture, breaches commendably ignored to get the job done.

We shot, and killed another innocent, unarmed.

Tear gas, fire bombs only in the dark of night, protest during the light of day you cowards, so our sharp shooters can get you

back.

We can no longer sleep peacefully on our beds, grieving for all that is lost.

Never Too Late

Don't give me the total runaround, that you don't want to be receptive, to what you don't want to hear.

So maybe you are disinterested, you are spirited in the wrong emotions.

Connected to that which is communicated, all that is glumly misconceived.

You don't have to be attached, pay attention to those values only that appear relevant.

There is always the risk of thunder storms in the sunny skies.

Furthermore, underneath some fiercely guarded hidden rattlings in the drumming of the sweet

inclinations, made so much more attractive, resources that are untapped.

Must you boast about your own real merciless malcontents.

With an intrinsic compulsory reaction one participates with apathy, kicked up a notch.

Arrogance carried it too far, with insipid remarks.

Pointed out the weaknesses, instead of the exhilarating discoveries.

Warnings are unappetizing, so awkward, difficult to dispel.

Disintegration of the paralyzing effects, that disbelief emits.

Icy oppositions accumulate supporters in unending superficiality.

We have to pay attention to the everlasting, not to that which is ephemeral.

Those that enter into our lives have influence that is briefly regarded, mean that we were wrong.

A genius soars above the fray, into sound resistance to the negative vulgarities.

The mission is to show up fully, to take importance to the centre.

Open up to the taste, to the smell, those sensations, letting go of guarantees.

Though you made the vows, you became abstruse with constant engagement.

Reactions

Just go with it, thereafter is a separate thing altogether.

Philosophic cerebral contentions can make us gravely miss out on pleasurable things.

Underneath our feet is buried all that we just don't want to see.

Just hope some day that we bump into it. It may be exciting, it could be huge.

We just couldn't help ourselves when suddenly that smile came over our faces.

It was with great relief afterward, when I screamed at you about my frustrations.

Squeeze out the enjoyment. It may be hard to come by in a different time, and space.

And we put it in rhetorical context, can sex be considered safe, it is such a crazy concept.

The natural inclinations that are long denied, pop out, not in an unruly fashion.

One probably didn't think of it in that context, when so young you took it seriously what you were told.

Perilous circumstances ensue integral instinctual leanings are disregarded.

The collision course is apparent so long before it occurs. Those that care the most, are the most vocal.

The look on their faces essentially belied the viperous intentions

obscured by light.

Many uncoupled people still love their exes. What a folly to behold.

Dare to engage in regrets, though you tolerated those strenuous moments in time.

Not every value is made of titanium materials.

Herculean forces would truthfully admit to the immensity of the task.

Strength naturally stems from backbreaking resistance.

Peacefully participate in the honesty, no matter how much it may offend.

Becoming A Stand Out

You planned every step of the way, so that you could grab a hold of your fondest desires.

You didn't blink an eye at those your actions disfigured.

Immorality is an expression made up by wimps.

Your manly calling behooved antagonistic predispositions of enormous complexity.

What the audiences are buzzing for, all things perceived as must-haves, your essence apprehended.

The interest was captured because of your distinctive perfections.

Your ascendency proceeded your physical presence.

Unaware of the weight of your importance, made you all the more attractive.

Disbelieving in the expressions that just came out, but were undeniably effective in the greater schemes.

You put out only that which you truly believed.

Careful not to hang on to the ones who had not an inch of faith. They discredited themselves deftly.

Doubters were but subordinates, you are the ultimate being, you are the king.

The one thing you were talented in, you made sure was long tended to.

You shrugged off tilting the centre of gravity.

What did it matter that your thoughts manifested dishonour.

Childishly, you showed anyone within ear shot, just look at what I've done!

It is irrational to say that you felt alone in our antagonistic life, you brought many close within.

It was fear that kept them enraptured. There was no preference shown, to be part of a free flowing

love.

Rock Star From Mars

He's going to one-up you, whoever you are.

Pull up those pants, don't let anyone see you undone.

I don't need to thank those who faced unspeakable indignities.

It was a service, they were the servants.

Life is an endless celebration. I can do whatever I want.

People are veneer, simply put, they are decorations that I flaunt.

I don't attach any credence, that I will go down in history, attached to shameful infamy.

Forget all you used to know about arrogance, this is braggadocio of unthinkable conceit.

Like a soft drink sized large, eclipsed next to the super big gulp.

My ego is of intimating proportions. It's a satisfying adrenaline rush.

Let me play with your concerns, like a cat with it's target mouse.

Animosity doesn't even begin to cover the anger that I feel inside.

I am supported by my gang of acidic characters.

I am down for the fight, I run the street activities.

It is so fun when I am doing it, it feeds all of the needs that I have.

A soldier against scorn, haughty resistance, the bad-ass respected.

These are not airs, this is authentic, I am committed, all in for this, though you may laugh.

I am art deconstructed. A parody of normalcy.

There is no strain of disease stronger.

Stubborn beyond all compare in my stance.

I entreat all of the detractors to try to stop me. The more you protest the more I am fed.

Commendable

You are a true blend of vigorous enlightenment. Precise excitement abounds.

Imprudent feral friendships were exposed as counterfeit. You did not need that insipid chorus.

Blast into the challenges with pure motives, so what if they trumpeted their full discontent.

Apprehension is a dime a dozen, often times premeditated.

There are so many who have too much time on their hands.

It's noon, oh hurry, it's, *let's give someone a hard time,* time!

Like professionals, they rise-up, and come out to fulfill their surly goals.

There is a smooth, classic dance to glide past, to disprove the disagreements.

So, on a most important day that was marked upon your calendar, they didn't want to show up.

It's the rule called Murphy, everything is cool.

Yet even Atlas who had so much to do, made room in his crazy itinerary.

The disgruntled will always have something to be disgruntled about.

The smooth, savvy, effervescent beings will always find the energy.

Eating humble pie, and enjoying it, is what it's all about.

There are behaviours that come in waves, and there are ones that will defy repercussions.

We may have absorbed some things that go against being serviceable to us.

Shock can ultimately cause miraculous undertakings.

One was brought out of their comfort zone, made to face nasty weather.

Permanent resilience built-up, while you weren't paying close attention.

Those who believed in you the most, will act as buoys in the turbulent seas.

Remember, those wicked winds are inevitably part of your risky continuance.

Messed Up on Sesame Street

It's so bad, they totally screwed up for real. No one was left unscathed by that ordeal.

The lethal turn of events seemed completely out of character.

So discomfort, irritability occurred, but didn't aptly name it.

What is acceptable, best, or true for you, doesn't always meet the same social standards.

Yelling, name calling, cops being called on to the scene, is somehow part of the daily interactions, regarded as normal it seems.

Redemption isn't even considered an option.

It will blow over in a matter of hours, the mess will be cleaned up, and not a word spoken.

Maybe this is considered messed-up in the best way possible.

We fire passionate words at each other in fear, the only other emotion there is.

So who are the ones expelling the saying that we have only two emotions?

Psychiatrists paid handsomely by the big pharmaceutical corporations.

I believe there are so many manifestations, there is no proper mind control.

Baby boomers took it all, Generation X was without a doubt on a long downward spiral – not to come to a halt, no, not, never even,

world without end.

There's Generation Y on a collision course with gluttony, like the boomers once again.

There's no end to hyper-consumerism, there's always a one-up, something better.

Generation X'ers befriend the new ones, the Generation Screwed, in an open offer, at least not like the silent majority, who didn't give one shit.

Come to terms with the underlying facts, it's up to you and no other, to make your own way.

No there is at least in us a conscience to give you the knowledge to go forward.

We want to talk openly about it.

Prepare to be captains of your own high virtues, get a move on, in the right direction.

Do the Right Thing

It used to be so complicated, so difficult, almost unheard of, at the least boring; morality.

At one time it may have been referred to as having established values, even a set of mores with exquisite manners.

Right now it's more far removed, it's called ethics. Such delicate questionable schemes.

Lowbrow, tasteless, insensitive, obscene dissonance.

And proud to be subservient to graceless subsistence.

Rarely born unto these types of conditions are we immune.

Successful ideas used to take years, even centuries to be proven effective.

At least we are willing to be participants, to impart the pertinent information, free of calamity.

It's certainly worth while to serve you well my dear, my distant friend.

I can't remember the last time I consulted my sanity.

The commonalities don't end with being of the same race, the same sex, or the same blood.

The worst enemies exist in the very same neighbourhood.

There's a flood of creative energies enveloping the thousands of millions.

What is it that makes each one of such remarkable compositions?

There was no rest, no mechanism for failure in that divine corridor.

The fingertips were going hard, they were worked to the bone.

They trudged through, snow, sleet, rain, and the driving northeast winds.

Our ties unbind us, our friends let us die in haste.

They don't know to whom it is that they pray.

We have to make it work, every core energy makes one very huge difference.

Remember well, we are all in this crazy thing together.

It Has to Be Done

I have never wanted to quit something so bad.

We have to do this, we have to finish that, we ought to have known better.

Where is the trust that you can find so that there is just one soul you can trust.

I've been on a roll, I've been on the road. I have been paying attention to the traditional elements.

Join the club, take back the power of that which is considered a brand.

It may be the first time, it may be the only time, you are there for me in my impossible hours.

I may say that I am at my wits end, you gave me the huge release.

It's preferable to take the stance of Leonard Cohen, the timing might be out of step.

Every stretch of existence comes with a fleeting sense of apprehension.

So now you are really taking a risk by appealing to only a handful.

It went much better than expected.

The reticence, defied common sense, which is actually so rare anymore.

They tackle the trivial way before what is in essence much more pertinent it is so easy to see, it's transparent. We don't even take

note of our own well-being.

Nothing is everything.

It's so bold to suggest that it is like nothing you've ever experienced.

Imagine that eating their product will indicate our sense of pride.

It's kill-joy, a criminally commercialized society.

People will supposedly only remember your work for the opportunities it gave.

Find a universal, utilitarian theme to take you back into the forest.

The inner gallery can only be appreciated as a terrific centrifugal potency.

Ladies and Gentlemen....... The Beatles

Burst onto my wider conceptions the melodies, the instruments, the booming loud choruses.

The Fab Four fell with heavy impact on to the rather dull TV screens.

John, Paul, George, and Ringo, each one an entity on to his own so young, so creative, so very clean.

The crowds had no other way to explain the effects of their mere physical presence, except to scream.

They were brothers, young, tender and eyes wide open in their bubble, as one together.

At first we didn't much mind what it was that they were actually saying, yeah, yeah, yyyyyyyeah!

In their own absolute perfect, genius, musical madness they swiftly went full in to the unseen.

The concepts took on a much more far-reaching humanitarian love induced revolution.

It was the pinnacle of existence, meant to bring out the greatest natural pleasure, it was really all you need.

The narrative got overwhelming, each one heart, soul, mind, and body, all-in-all, for the same theme.

The ramifications were so enormous, it wasn't what they had conceived.

And John poked fun at Paul for selling out, for telling everyone exactly what they wanted to hear.

John personified his fantastical, spectacular, implicitly beautiful dreams.

George soared above on that velvety, painstakingly cared for, cloud.

Ringo convinced himself of that lifelong cherry on the top of his sundae.

Each one of those Liverpudlians gave us their lives, their wisdom, and transformed their powers for all our own good sense.

When we listen, even to this very modern minute, they continue to heavily influence our feelings.

What the Beatles tried to say was to always be true, and help you understand.

It's all about a devotion to tender, deep-seated emotions.

Now what was considered unorthodox, is presently considered classical.

An invisible, yet, invariably enjoyable thread comes forth in hearing their music.

Universal relevance, under the absence of silent fear.

Notoriously Known

Everyone is late for school, the dog ran away far from the kennel.

There was a ruckus when your family told us the latest treacherous potential.

Not enough is left for you to work with in a dimensional rough transition.

You have this way of making people want to show their red veins.

There is a need for space.

No one aptly explained that there are never ending series of events to make prodigious decisions, just about what it takes, to haul that fine ass out of that California King bed.

How be we tell you to disassemble all the traditional elements.

Try to explain that impossible, possibility, in that ugly universe withstanding.

Distress is the look of the day, it's chic.

We left the machines to gather information.

We insist on not liking one another. The machines they are so slow, they drag us down.

Convinced that the brains can only reach so far, that's really not the case.

Ceaseless, boundless, potentiality, the future is more, and more revered.

We can give back, what we selfishly took from, the now.

That incline was high, that price was much too out of reach.

Kind deeds can only lead to worse things.

Injustice is a slut in the face, of what it is to be considered fair.

It's so far in the nebulosity. Things that were hazy in the moral underground.

I sit behind my thugs, my brood, my liars, my lawyers, and that doped-up crowd.

Open the eyes to this unrelenting reciprocity.

Nice work, you!

The Scene

We rounded the corner with complicity, but realized that it was welcoming us thither.

The thunderhead clouds were that wall; so it feels like it's all about lightening the flow.

It gives an appearance of spaciousness, money so well spent.

It suits us so well, how cool, it's just so much fun.

If fun had to do with functionality; this serves as a useful premonition.

This is it, it can not be replicated, nothing takes such serious precedence.

There was so much more that needed to be said, to take us to that point in forever.

Our specialty is to have that comfortable home, that one sacred, perfect, peaceful settlement.

May you only in your most genuine loving dreams abide the bond that is between such as you.

So what if anything have you tried to add to this brick wall of surprise between.

It was to be a simple resolute, benevolent intention.

Was there a sinister mind at work, at play?

It was a gut job, sickeningly so.

The foundation was below

the footings of up above.

The proportions are off, can't be enclosed, one can't have a proper fate.

I was a sloppy, defected personage to influence my fellow citizens.

I was contacted several times, I didn't want to answer.

It flies in the face of evidence.

A lot of digging, it's takes robust loyalty.

You can not look kindly on regret.

Let Me Show You

There's a huge span of space that I must put the load upon.

It was in place, but someone pulled it out. It was a shift, it wasn't a horizontal fall.

It is just instantaneous, no settlement, caught early enough, it was something we could deal with.

It may be neither one way, nor the other.

My big wish list asks for what is currently up to code, not what was previously.

Running to determine whether we may weep.

It is imperative to decide just exactly what one needs to do in the least resistance.

To literally fall apart is psychotic, it's at every mercy, it's totally issues off of the grid.

The magnetic signal is tracked underground, the place we ignored the most.

It's clear to control where the flow is around, to where you find your place.

It's probably more work than you were expecting.

I bet you could get used to it.

The silent ones died very unexpectedly, though they didn't have the body to give us the message.

Reinventions luxuriously enjoyed in parts, never thought of

before.

It is a fast melt melancholy unprecedented, the absolute epitome of the perfect storm.

The love easily adopts to a safe accommodation in the open, for all to have a look.

Hidden, loosening, not just because, because it's a requisite.

To live the dream, in living the dream, not one instantaneous move better than the rest.

A maximum lateral formation keeps the rest in peace, in your favourite stead.

It's naturally beautiful, the results, the deep denouement.

Hydraulic masonry to ensure that we are here in thirty years from now.

It May Be Broken, Going No Where

It's happening, there cutting corners, they are going no where.

Years ago they were permitted. Inspections were missed, the resolutions are left in other hands.

All those by-products of hatred in the disguise of refreshments, with guarantees.

If I wasn't doing this, I would definitely want to be doing that.

A grievance to reduce the natural healing process. Just do it, and be done.

If it's not covered, if it's pursuant in the circumstance, meet a lot of people to not be nervous.

Redundancies means it is bleeding, hemorrhaging, going through a lot of extremes.

Just listen to me, give me your input, I may just go ahead full steam.

The crafty guru ninja lover.

You wanted the uppermost sensational unreasoning superb relationship.

It wasn't even at par with what is out there.

You didn't just visit there, you stayed, you belonged, you converged.

You switch for comfort over inconvenience, it was done over, and over again.

It's old, the last transition was a bad one.

It flowed like hot sticky lava, it was a hot insecure dead end.

Your life's purpose blew a gasket, the toilet was flushed.

The bigger picture is given full due.

It's time-sensitive, so many think they can do it very easily cutting their losses.

There's a natural expansion, and a very difficult contraction intervening.

The standards are fluid, the life outside easily dismissed.

Doubled over with laughter, so serene.

Sir Thomas Hardy

Southwest, and south central England is where you perished, and where you grew.

Born into to a staunch, crusty, morbid Victorian society;

your style was to pour on the complaints thick.

Sir Thomas retracted the metaphysical permeating dalliances for those that seemed out of place.

It was a harsh new reality, stale, fundamentally, stiff upper-crust.

Hardy championed the rural cast-offs who struggled against their own rapid demise.

Reasoning explored the burgeoning need for social reforms.

Inescapable were the degradations of those in the lower ranks.

As an architect, you moved all of those soul's graves to make way for the railway extension.

Hardy had a heavy hand in building up public spaces.

In serialized novels he blazed a trail to originate the cliffhanger ideal.

And Tess the fallen 'A Pure Woman Faithfully Presented', ruffled many feathers from on high.

'Jude the Obscure' considered much too sexual, so blatantly obscene.

It was in poetry that Sir Thomas hit his stride with heavy influences of Wordsworth the king of the

romantics, and the romanticism scene.

He earned his place in poet's corner in Westminster Abbey, along with all of those who came before, and after.

We can all see characterizations of our own lives in the people of Wessex.

Surpassing the boundaries of a social status predetermined, or sanctioned many individuals.

Pastoral landscapes win over the crowded city living quarters.

Hearts are full, love is foolishly young, with time as the enemy

The eye of day weakens, twigs are bleak, thrushes are gaunt, and frail.

Impact, clout, and notoriety mark his inconspicuous significance.

Bid Farewell

Many, many potential compromises asked of you, with every action, at every turn.

Right now our hearts are in the city. We decided we were such big fans, so we rearranged.

You were one in your desires to come off your high horse, and loosen your preconceptions.

It was something that you chased, your passions attained; meant to put aside all in survival.

All systems in gear to make a splash, let them know you're here.

I was always the number two choice, number one got all of the attention.

Only through erring with strong infusion of historical dimensions, can you see right in.

The layout exposes the gray. So close, but away.

I could have been what you really liked. You may have been underwhelmed, all in the same day.

Each visit was a plus to make the perfect sight.

There is old, and then there is vintage one-of-a-kind, to be appreciated, to be treasured.

Unnaturally visibly unhealthy persuasions.

Interests piqued, interested held on to it.

You were only too happy to roll around playing with the lion.

You were not forgotten, you were not overlooked, you were missed.

Degenerated forces likely stopped, to confront an ultimatum.

Satire suddenly changes the primal notion. You said the welcome period had expired.

I rolled my eyes, shrugged my shoulders, and tried to ignore the hurt.

It couldn't possibly be true, waves of humiliation building to a crescendo.

The rage escaped, it filled up the entire room, it flew out the window.

Give it not one other second of pause, it is far away now, a speck upon the horizon.

Talk not of grave motivations, with harsh consequences.

In the best styles one can be a creator with intelligence, with perceptive souls.

The Page

If we were in a catalogue we'd be in the same department.

Shattered memories, one spotless childhood.

Treat all as one, and the same, all want to be accepted.

A portrait that does not include the entire scene, it simply skims the surface.

They were dragged through all of the rigamarole, then primed for subjugation.

The senselessness brushed aside, the dust wiped-off your pants.

You must run when you are called upon, put away your ancestral pride.

Daring to rattle those chains, to be the cause of that stink.

It smites like the burning of a hard slap, or a vicious whip.

If we are to believe in this, to be a pure substance, in this surreal panorama.

You could be the key ingredient in it, mixed-up, no one could tell the difference.

You bought into it, it helped you heal to throw off those who cared not.

It's all free for the taking in the universal institute.

Scenery deserves to be more than just a backdrop.

Happy endings for enlightened ones twisted.

To pretend becomes the obsession.

Get behind it with all your might, embrace the lyrics to the songs.

Don't accelerate in haste to polish it off, to gulp it down, to devour it in full.

Imminent warnings beckon with relevancy.

Take up arms against deprivation.

Be mindful in the face of redefinitions.

There is no leeway, no room for denial.

The Fates

Where are the places where it settles into a place to hang on?

Factors are just where they insidiously travel into regions of wide importance.

Come forward to report the scam, mitigate further harm.

The locals are pulsating with misplaced strategic energies.

They told you it was all in your best interests, it was all just for you.

The corporations swallow the lower tax brackets, unnecessarily identified.

So unfortunate that the public pays homage to the noise.

I need to be near, I need to see you

the hands of rockets.

Suppress the discontent, the clashes, the disagreements.

Put away the prayers for higher preexistence.

There's no hope, no remedy, to stem the tides.

Man made manifestations not close to withstanding the predominance.

The curse has got you covered.

There's no use trying to feign graceful acquiescence.

Unbelievable

One needs to shake their heads in dismay rather than agree with the destruction.

It's was externalized evenhandedly, a precisely measured set up.

For those that can feel shame, it would be at an all time, ostensible high.

There it was for all to bask in, oddly they were attractive non-restrictive elements.

Do us all a big favour, and next time, try not to have so much pride in your tacky proclamations.

That strut was much too garish, for any appreciation.

The compassionate were hushed, they just couldn't control the embarrassment.

The memory unfortunately does nothing to quell the effects.

Visions are utterly unforgiving.

The passage of time serves the rustic purposes.

All trace of the baby who owned the show altogether wiped out.

You invited yourself as the presidential whore, into everyone's beds.

You bragged so well in advance. No one wanted to hear.

It was nine hundred degrees, and they wore black leather.

Played up to the abrasive self indignation.

Nothing good could ever come of it. Cover ups are considered chic, with higher style.

Clearly human tragedy gets much more time.

This may be but one purpose, to live this.

Not enough point of view to see any other way.

Releasing, unleashing, subconsciously living to the fullest degree.

A Million Miles from Normal

There is no referral for, nor demonstration of, what it is to be a dominant player in the scene.

It was placed up upon the grande marque judged by it's popularity.

Representations persisted so that onlookers could escape.

Making some eruptive moves without even wanting to.

Chaos is the reverent guide.

You cry at the beginning of each day. Many faces animated by fear.

Might as well do something fun, something to enjoy, if that's what you've got to do.

Dramatically strong personalities get you to change your tastes.

Dazzling diamonds were dangled in front of you.

When you needed it most, it didn't show up to fortify, to add to your day.

You bought up all of your shares, you got what you thought was such a good deal.

Was it what you expected to see for yourself?

Act like it's the end, and go for it!

You had to stay, you had to grow, you had to find out what it was all about.

Slender chances, old time, overused, under productive pass times.

You've impolitely declined the benefits. Some of the premonitions disregarded.

Hanging in the air, a million miles from normal.

You've got to be fast, you've got to dance on cobblestones.

No way to avoid the binges. That's part of your nutrients.

You tear into every amusement. Load up the portions.

You know of no other, better alternative.

The last time you were beholden to another was long ago.

There's No Value

Extractions of scenes to beware of, one who runs you down like a grizzly.

Don't worry about it, this is your state of mind, you'll have lots of time together.

Brilliance of refinements' subtle streaks.

A sniper finds a way to effectively gun you down.

You're talented enough to convince everyone that they're worse than you.

He tallies his results, he makes his commission every month.

Troubling screams, zero to 360 in a matter of seconds.

You listened to the command, you produced, and you choked back tears.

Some of the hits were bruises, some of them were deep cuts.

Accolades rang true, they came in by the dozens.

You are contributing to your own gross neglect.

Why did you bust through all of the road blocks.

You could actually have a fit.

The need for tranquility met like it was an affliction.

The gate will not open until you hit at least 60 years old.

You can't just ruin something without some kind of fight.

Reclaiming your integrity.

You can have more than a bowlful.

You've earned the right to your spotless reputation, your impeccable tastes.

The endless sea of friends that you cast into the world to be free.

They impregnated the wrong person.

You just stand there emotionless taking all of the blame.

It seems that you just don't care.

What is Your Issue?

You wonder why people don't trust you. You quit so that you could be all done.

You can not see that you have not been trustworthy.

Maybe if you got away from the scene of the crime, things could be different.

You can't even understand the root of all that evil.

To comprehend is not in any way appropriate. You've refused to put up with all my shit.

Register with the forbearance in the land, of all those who constantly disagree.

The crippling elements block everything.

Allegiances to behaviours committed to fear.

Your entitlement disgusts, it doesn't get you to where you need to be.

You exploited every possible option.

You've got charges against you for miles.

They inventory all of their injurious deeds. They have them lined up for blocks.

Their limited resources dry up very quickly.

Mass productions of noxious constituents, a strange brew.

Historically you need to be in your element, and only your

element alone will do.

There's a very easy way to make your day, I got it on hold for the moment.

I'm still licking my wounds after the last attack.

I'm not ready to put down my weaponry.

I swear I have the lethal dose.

I Would Tell You

All good things actually come to the same conclusion.

I have the malicious components, they're right here by my side.

I tend not to be able to leave these things behind.

So if you dare to tell me your resentments, I'll scatter the contents in the most hideous places.

You'll not have any advance notice.

It's a painful, instantaneous take down.

It's mandatory, not one single soul is exempt.

You must comply.

At least I'm telling you this right off the bat, you better take cover, and run the other way.

Like a big scary monster, I step heavily, my feet are as heavy as lead.

I am doing more than ever is required, there is everything that you owe.

It's simplified, you just have to do it, just like everybody else does.

You don't even know the rules that you are violating.

You don't trust yourself enough to stay behind the lines, there is no other way.

Mercy never rusts, it continues on through all strenuous

complications.

There is no bait, that you did not willingly take.

There is a bottom line to steer towards.

All was conspired, that which you teach.

Get up off the floor, battered, beaten, and torn.

Get into a structured environment to partake of this triumphant reemergence.

Respect the Guardian Angel

He's the one to give you the nudge, to gather the guts, to veer on to the higher path.

Hey it's just what you needed, and somehow out of nowhere, there it came swooping in, that

inexplicable nurturing force.

He read the situation, came in as reinforcement, without being called upon.

He understood your hesitation, before you made the wrong choice.

He didn't want to see your indignity, at having to make you plead your case

You were compelled to make a formal apology to never do it again.

He acknowledged your better judgments, your gratitude wasn't fake.

He smiled at you from the other side of the room, while others tried to smite your character.

He recommended the exercise to relax into confidence, to enjoy your strengths.

Even some considerable weaknesses are coveted.

Gabriel is that fabulous interior decorator that specializes in interior panoramas.

You could make a list of wishes that already came true, that the

angels played a central role in.

One marvels at implicit combinations that the angel may carry.

They sing like they're coming from heaven so far above, the innocent melodies, the hushed lullabies.

They hover just above the earth, or step on it with airy fluidity.

They make graceful, congenial, fiercely loyal companions, even at the best of times.

They carefully make way for the quality-rich time to spend with you.

Rest assured you'll get that close contact right in the nick of time.

What you have lost just pray to Anthony, he'll bring it back safe.

Christopher will make sure your journey passes without incident. Mary is full of grace.

From Francis, the wild animals have a clear undeniably important voice.

They Asked Me to Speak

You were dead-on, lets get that straight.

You supported that sordid cause, there was nothing you could do about it.

What if you were told you weren't even invited in the first place anyway.

You begged, you wanted to go astray.

You didn't imagine that they would make such a fuss.

It's a pity that I don't care one way, or the other.

I theorized that one only gets what they asked for.

Therefore, it's absurd that you would actually ask for that.

High praise goes for the way that you handled it so smoothly.

You didn't do it to reap some type of material reward.

That's an insult to the original mission.

It's a unique bond this treatise.

You are silenced by ferociously wild cold hands.

You lit up when you saw the guest list of dubious characters.

Your influence forced them to clean up their acts.

After all, it's worth it, preordained, it's possible to disprove.

These are only allegations. It's one permanent shift, not at all on

the radar.

It indicates where you are in your heart, of hearts.

You are no stranger to success, your inner David becomes the best of friends with Goliath.

Distinct impressions are laughably inaccurate. There isn't a morsel of truth.

A remorseful towering force, some bitter sensibilities made the corrections, and were bang on.

Just the perfect timing endured to bare witness, to bless you, amen!

Darwinian

Make no mistake about it, complete change is a healthy state.

The transitory phases were the most difficult to traverse, in this Darwinian marketplace.

No one can predict how long for the effects to be felt in comfort.

To adapt or die, that's all that there is.

It came that way, it was unfurnished.

It took millennium to form, it wasn't as what was described in the book of Genesis.

We more than entertained those lies.

Some durations move at slower paces. The species, they do develop.

Only one can account for the subjective spirit of circumstance.

The heart holds the head hostage.

I've lost too much to be whole again.

Abandoned, left in the empty wreckage, direct contact with your inner resources.

There was so much there on offer. The stand is strong to be diligent.

There are stakes that are subtle, and there are ones that are obvious, that can not be ignored.

We're torn apart in many ways, day by day, in this destination.

The staunch supporters never waver.

You experienced joyful participation. You were not spent, you would not be worn.

The isolation was only a figment of the childish imagination.

You can tell that you were fit to use that generous commitment to thrive, to be happy, just to be.

We are closer to the mysteries than we at the onset, surmised.

We take part in the nature's wonders, the permeating laws of give, and take.

Toxins

There was only just enough to get you whipped.

No more could the actions be foretold. A magic spell braking into the boundless, terrible ills.

The thrills were so real, he wanted to be present.

The past was much more silent, when it came to giving us the answers.

In the incubation stage, the exposed failed to warn us of the inherent dangers.

It filled the void for a while, it felt like home.

It was so easy to cover up. No one ever suspected, not one corroboration.

It

this.

No part is to be skipped, no revelation less weighty than another.

Each atom can not be sliced in half, they so enjoy a congregation.

Madness is the only way out, if you had kept up that furious pace.

The body can only do so much to ingest those all-encompassing poisons.

Taken from materials not usually associated with humans.

You use that beacon that you buried on that bleak street.

For reasons unknown you are driven despite the facts.

Balance is too normal, bold is the way to go, you are the creator of that funky scene.

What More?

There can not be more than you have come to expect. What more do you want?

You're married to *dynamite* in the flesh. So terrific to be with right to the core.

Greased Lightning looks like a rusty *Pinto* next to him, you couldn't possibly ask for more.

At this stage, the fire is lit.

Equality never lived here, it's something they say to get past those dreary moments.

Accept those non-material rights of passage unto places of relative amusement.

You were asked to replicate the customs. No free reign on values, relative to your soul.

What more do you want other than to be nearest to your youth.

One realizes that there are times that are cut much too short.

To want more of anything, one would have to request just a little more time.

The hands on the clock were given just a one second glimpse, we didn't respect the ramifications.

Stop pointing that saucy finger at me!

This isn't a popularity contest, back away gracefully on your tip-toes.

It is the most, there isn't any more there can be.

You need to adjust your highfalutin expectations.

Don't lose your capacity to reason, it may come in handy.

How it will all come together, it makes everyone wonder.

A clandestine meeting, who knows what put you up to it.

There is more, so much more that you have to share, to give, to help those who are blind to see.

Somewhere right now somehow, there is always room for more.

Graceful Pressure

There's a need to be restlessly innovative flourishing out of sequence, all around.

Scrambling around in the hush, crazed notions are robust.

Try not to hold back anything.

Step up to that plate to finish, despite the odds against.

Welcome to the dimly lit room in use to shore up the privileged intelligence.

Performances got trashed along the way.

One beautifully harmonious discord.

The positioning is vulnerable, the errors are hapless, no forethought in evidence.

Even with a loss, one can use finesse.

Irresistible inclinations, rarely get the best of us.

Bought right in to the ownership.

Help yourself, you're welcome to it all.

The possibilities are your fuel.

Brightened by a release for disappointing grief.

Take the concentration away for semantics, you know exactly what I'm saying.

Cynicism lays it all to rot.

It has everything to do with the way that you look at it.

Find a constructive way to burn off all of that tension.

I'm not going to shout it out, I'm not blind, I just can't see right now.

Heathen

Humour the dead woman, you may not have a choice in the matter.

Have at it, I wish you well, you deserve respite.

One can always broker that back door deal.

Dispense just what you need.

It was something that was revered back in the day, today not so much.

You jammed it down my throat, I didn't even send my RSVP.

He is so boss, my mind went all over the place, running around, the wind knocked right out of me.

I paid my price of admission. The show totally sucked.

Your personality came out of the woodwork.

I couldn't tell you something you already knew.

I'm at fault to want to disprove your suspicions.

You're a feisty titan, with a heart made of tin.

You know damn well what I'm talking about.

I'm determined to turn this around.

Once considered a devout follower.

Now I am proud to be a heathen.

Sleek Modern

Keep in mind that sometimes it's a tail-spin situation.
There's more stop, than there's go.

Rustic acclimation in this modern-sleek world.
A marathon of people flipping-out. A miss-mash of uncontrolled emotions.

You have to get that ticket to be let in, you have to purchase a ticket to win.

Have that done without too much damage.
The engineers are the first ones to start laying it down.

I can be quite ridiculous with my whims.

We made fire, there has to be more that we can do.

We create miracles, it all comes from the fabricator.

Look back, we must in order to take it to the next level.

We brought it in from my living room screen, the dreamy sewer worker with his lonely hearts ad on

Craigslist.

The plastic saves us from the splatter.
Throw a party in the kitchen.

You look like an alligator, but I picked you up at a frat house.

Your smile got me. I was in Sugarland.
It's a marvelous excuse.

Canadian Poets Are Rock Stars

Let's face it, they're an elite group, just bursting out on the scene.

They're rogues gone wild, they've got elegant desires to expose world class themes.

Doesn't colonialism make you uncomfortable all of the time, really what was the justification?

You just don't want to be associated with the selling, and packaging of the ideal known

as democracy, it cheapens the original intent.

Though living above a meth lab is not ideal, at least we see every day, what we aspire not to become.

This is what we're thinking, and it's definitely fine if you don't think so too.

We have a love for all those noble properties, we will not be consumed in the name of pride.

We're not going to leave you out, not to be considered just too wonderful to be talking to you.

He's made some big mistakes, our leader.

In the majority he's flying around with his humungous dagger.

It will take a mighty wrecking crew to destroy those corporate cheaters club tax structures.

He's Machiavelli dressed up in a Canuck's uniform.

The man is adept enough to steer our natural resources into the
hands of heroine addicts.

We've breathed a collective sigh of relief, our fingers pushed
down
hard on to that eject button.
This is one very practical arena.
It is our due to set the pace.
What an enormous threat, it's seven times the expansion.

Access

You've got what you always thought you wanted, total unlimited access.

Forget about that bird's eye view.

On high, you look down upon all of your dominions.

You are rank from all of your power.

It skipped your mind, and blew a dark hole through your emotions.

It's magnificent this view, it's the place to be.

It's certainly pricey, but I think it's doable.

It's right in front of you.

It's no trouble at all, you can be lazy.

It was a shut-out, a win in this context.

Generations before they sent you to the gallows.

I'll sit this one out, I'm going to take a pass.

I'm not at a loss without your friction.

Obnoxious

It's always more than words that are spoken, it's the silence that is way more potent.

Your aggravation comes through my defensive amour.

It came barreling through my delusional force field.

You know just where you can find me.
I'll be at the bar drowning in booze.

I've just met a new friend, it's an investment I've made.

I use the novices to prop me up, cover me with a blanket when I pass out cold.

I'm not aware that I've told you the very same stories at least sixteen times before.

I don't want to contribute, I want to get left in the dust, it's easier.

We're everywhere, you got your: veritable crazies, the looney tunes,
the nut jobs, the scrambled eggs, all of the minds that are unglued.

I can only stand by what I say, I'm just not that into you.
I'll make you believe me, it's what I do.

I walk all day long in bare feet on hot coals, I sleep with my eyes open.

I've been known to want to turn water into beer.
Whatever I am quarreling about, perhaps I'm sorry,

I may have conveniently forgot.

The Dumb Ones

Cumulus clouds telling of us the danger ahead, but no attention was paid.

They just didn't know what it is they ought to say.
For decades now it's been this way, you are fed the information they formulated.

You don't want to be called to the mat, and be scolded.

It comes pouring out, there's a leak, some sort of security breach.

The pattern will be impossible to decode.

Somehow the inescapable truth crept up on them, and they woke up from their lethal slumber.

You popped out of the uterus, and crashed into the computer-verse.

They shuttled you in with their depth perception.
They see all of your personal effects.

The knives, the guns, the bombs; are for all who can't afford it.

The arsenal they've chosen for you is much more effective.
It hits you right into the central window of your bank account.

If you've always live a good life, this is going to rearrange it.

So like Bette did say when she set the scene, "Fasten your seat belts."
The big one is heading to the shore
You know you mustn't sit this one out.
You are at the ready, alert, absolutely secure.

Solid

Rumour has it that it used to be a reputable establishment.
Then they treated it like it was something detached,
some obscure object.

One intervention later, and the pieces were dusted off,
then repaired before being put back together.

What a filthy, stinky, sweaty swamp!

All this algae sticking on to the rocks.

He loved you gently,

that's the only kind you want.

This isn't the stuff that anyone actually wants.

These are the sad looking hand-me-downs.

They're not some cool vintage designer duds.

You're so scantily clad that I don't want to be seen with you.

The idea is to highlight the good,

not that things that have,
or perhaps can, go wrong.

You've got to write it down, that which you see that you can have.
It isn't necessarily all of the material things.

Right down to the bare bones of dreaming, singing, celebrating
this time of consistency.

Bright

I can't look right at it; it hurts my eyes.
You could describe it even with unintelligible tones.

If you don't know it now, you will eventually discover it for yourself sometime later on.

I say that loving is a bitch.

What a magnificently barren displacement.
An island that you can't wait to get off of.

It's sure to be agreeable that it couldn't happen soon enough.

I don't even know if you have any point of reference for the ridiculous.

It flows, it doesn't have to break down to compromise.
It just does, what it does.

I'm suddenly feeling the pull of the under-toad, big, green, and slippery.
He said, "You are my one truth, baby girl, little dove, my one desire."

Then all I heard was that heavenly chorus of Spanish guitars, floating into my senses.
I'd think the non-sensibilities are the only ones who heard it, I bet.

I have to have something that I've only surmised.
I know it's not there in your bag.
I realized, we can not *tra-la-la,* that this isn't the merry old Land of Oz.

Right Now

If you knew it right form the start,

or sometime before,

why are you telling me just now?

If it's a war that you want, there's plenty of that.

Name me any Wonder that you want to see,

and I'll mark that down.

We'll get to it.

Quit trying to grasp on to something else,

you got this here,

and it's not so shabby.

Analyze it with some type of guru disposition.

That'll clear it up.

I can picture that I lack the skills to endure this venture.

Blasted right for it like a bird pecking with his beak at his reflection in the mirror.

It wasn't so easy to miss,

It's not rocket science, or anything.

The paranormal beings are working in conjunction with the para-verbals.

You wear that scowl on your complexion.
The tension is making the earth buckle up,

Looks like we're headed for a strike.

Answer the door fast!

We all know that knock.

Mentalities

The impulses are beyond comprehension,

they seethe ever-present, ever-contingent, toward infinitely dishonourable satisfactions.

Envy takes a bow, it makes positive inroads to be destructive, even in light of diplomatic relations.

We had a deal, that we can rebel against, the pact that was made under false pretense.

Don't pretend to be modest, it's insulting to be that part of your personage

that is reprehensible. That side that you boast about.

With a false sense of inferiority,

you can white knuckle your way through all interactions.

I wrote this to your dedication, long before I met you.

There's a method to define what you want to achieve.

It's early yet, so just stick with it.

Motivate yourself to notice the results.

So don't give it away, let people adore you.

So that they are intrigued to get to know you.

There's no other greater embarrassment than sharing your desperation.

Empty your pockets, then maybe they'll half listen to you.

Though you seem innocuous, you may be able to make trouble.

Let me tell you this.

You are one wise mother.

I observe that, yet you don't run a very slick bureaucracy.

Style

On the one hand, you have taste that you can extract from another.

On the other, you have an innate sense of style.

It has not a genre,

Nor a label to mimic.

It's approaching the truth.

Grievances hold no value.

All that one can do is open up the channels.

It sometimes appears for no good reason.

Some natural luminous highlights.

Can't see to go in the direction of feeling run-down.

How sickeningly gitty could you be?

It's not a controversial topic.

Most people can see it is there, it goes beyond intelligence.

It's a blessing, a special glow that you are aware of.

You don't try, you don't labour over it.

Other people have not been on the other end of your frustrations.

Your Barbies are tucked away in the closet, with a wink.

I will keep my comments to myself, it's commendable, considering.

We're always in the process of leaving each other anyway.

We have to connect on a visceral level, that's what is so attractive.

You didn't know that what you did was inescapable.

St. Mary

You were that one who had to get away.

The mystically plain Jane that even God could not resist.

You were regulated in the public interest.

Old Joe the carpenter thought that joining forces with you would give him a name.

That old Joe was wrong in his fantastical estimation.

Mary's frail, tiny, incandescent hands almost let the baby Jesus slip through her fingers.

I knew that she didn't move you, like she often did with everyone else.

We talk to her, we ask her to bless us for our sins,

Now, and at the hour of our death, amen.

You were so poor, so naive, no one could ever know the sincerity of your humility.

With wide innocent eyes, you took in that you would be part of some resounding danger.

You would bury your son, who really wasn't yours.

Have to give him up so that we may all live.

And when he was 12, that kid made some very big controversial moves.

Though you went through this birth, you knew that you had to step into the background.

So Mary herself must be part of the divinity, her life was so planned, she has a front row seat in heaven.

Mary is the antithesis of war, she is the nurturing nurse,

the Mother Teresa, at the service of the disabled,

the humiliated, the disenfranchised,

the displaced,

and the unwanted.

Mary includes everyone, she works so tirelessly.

She is shamelessly merciful, while dispassionately the mother of God.

Va -Va- Va- Voom

You appear to be traditionally radiant. Now that's a kick!

Get it together so that you can get a whole lot more, for a whole lot less.

Who killed it?

Wearing red from head to toe, may just prove that to go into the room, is like going off with a bang.

In translation, it's a big miss.

Rocker chick is always in fashion, that's the stunned reply.

Look at the sky as a point of reference, not wanting to end up who knows where.

The ocean can appear as a black abyss, there you may find your luck.

To discriminate, one has to have gone out of their way to have a new experience.

If you can't get the unfavourable review off your mind, may you fight with another sight.

Make your statement, don't let them discredit you.

Remember your comely elegance, your moxie, with that attractive sprinkle of humility.

You have your rights restored, alleviate the controversy.

The claws, though sharp, are drawn away.

Those who judge, are putting their garbage out there, so they won't be detected.

Determine your own individualism, clearly stand by your decisions.

Things will happen, it's the human temperament, there's no use to that worry.

Situations can go only one of two ways. Take some measure to ride through the discomfort.

Prepare to hold back from inappropriate responses.

Traitor

To be fair, one goes there when they're out of options.
Demonstrate that side of you that isn't shown any other.
You need not to those you don't like so much.

It's a hidden wretchedness, with a heavy hand in treachery.
Take heed of the least infantile of emotions, this raging
intolerable character.

Values ingrained, not be exchanged.
Those traitors are working on the inside.

First impressions decimated.
No shrill warnings staring you in the face. Stay two steps in front
of the opponent.

Those higher cognitive functions made the connection.
Faltering to a situation much larger than you can control.

In the spirit of ill-will, an octave above middle C, racing through
the veins. The darkness is ever present.

Pay homage to the ones who got away.
Prerequisites suggest that one is snide, impartial, and indifferent.

Give up the right to ride into the sunset without a modicum of
closure.

Some have done it, lived through rough patches with composure,
against every natural instinct.

So the betrayal is severe, build some sort of
brilliant creation, one pointless distraction.
Endeavor not to promise to do things that you never will.

Where Peace Belongs

We, the makers are born to make some noise.
Peace belongs to those nearly, or really dead.

The alive ones are easily identified by their movements, no other indicators.

Some still breathing are all over the map, looking over their shoulders.

There has to be something else, they wonder should they succumb to the probabilities?
Perhaps we're in solid contention, promising avenues could become available.

Some classically emotionally charged spiritual awakening.
A new delivery of ammunition coming from all sides.

One must pause for grief that has it's own direction.
Imaginings, however brief, in wild formulations.

Strip down to the bare minimum, take with you only the items you need.
Time makes it's grave declarations, no shying away from destiny.
In a cringe-worthy moment, where one wonders at the need to grapple at the inevitability.
Like a child whining about the rules, even after being told so many times before.
Don't act so surprised when they have bumped you off their registration.
Oops! The government underestimated the precise amount of people needing care.
No need to know everything, there are some excellent, judiciously chosen omissions.

Ramona Joyce

The year of our Lord,1929, on a typically cold winter day, was the atypical day this earth welcomed

Ramona J.

The early years were spent in out of the hospital, carefully being prodded, and poked.

Like a candle that blows around in the wind, the little girl survived many close calls.

Through the guidance of a nurturing hand, she knew that she was loved.

Her only brother, her father and to her mother, she was the only feminine representative.

Regarded for her gifts, her beauty, and her quiet, not flashy, presence.

Her sweet innocence was tempered by sadness for the break-up of her parent's matrimonial union.

Those were the days when priorities to risk young lives were woven into society.

She kissed her soldier boy goodbye.

In 1947, the world was collectively under sweeping optimism.

The teenaged girl with the hourglass shape, full lips,

and cheekbones all the way to heaven, had met her match.

Joseph Raymond, only call him Ray, didn't want to waste one more minute without his girl so divine.

A marriage of souls, an earth shattering implication.

Traditional considerations marked by religiosity intervened.

Ramona almost single handedly, brought 13 children into this universal dance.

One will need to sit down, one will need some time for it all to sink in.

No one could ever quite capture how it must have felt, what it must have taken,

how much energy, how many surplus reserves, it takes being the matriarch of such a large bunch.

She does not have an answer, there's not a singular, all-encompassing statement to express.

You are content, just because you are, you laugh if God is willing.

She is blessed because she should see it that way on her epic journey.

What Matters

Add in condolences if it makes both of you feel better.

If it's only the conclusion that matters, why would you go through the trouble to take care along the way?

There is always someone else to manipulate the outcome. Envy makes a stunning entrance.

To have put so much work in to the finer points only to have your effort trivialized.

You hold on to those terrible reminders, while not doing anyone any favours.

Vision becomes crisp, no resistance to the red flags.
Perhaps you can love too much, too erratically towards that future, one can not handle.

We're on this extended trial, a perpetual metaphysical brawl.
Why now, why me, why when it's not the answer that you seek?

Memories are fuzzy with the most important information.
You are your own expert, in spite of everyone else.
So when you are young, you couldn't wait to get your hands on it.

Check out those that are near, they will reflect your impressions.

With so much going on, the bad vibes from others are just exercises in your studies.
Glean from the uncomplimentary, some hidden wisdom, it must be there.
Lift, stretch, widen your network of influences, there's always room for more.
It doesn't hurt to put in a good word wherever that may be.

Classy

His strut is top-shelf, a real class act is he.

Now is good, but later, . . . no so much.

One can hardly listen to him, they say he's lost his touch.

He is now just shaded. Just a faded shell. Character packed-up, and left this tormented existence.

He says when the concern expresses, it's that express bus on that road, to flagrant excesses.

She says, "This is a job for us two blended souls."

A fire burned right into the crevices of his blackened heart.

The lover fever must be contagious, like being stricken by influenza.

No more must we have to luxuriously plan for one iridescent future.

He is unstoppable, reaching for the best.

Pretty easy on the eyes, secretly envied.

Nothing wrong with a little Photoshop. Not in the least likeable.

Perpetuity is a gravely mistaken perception. Misconstrued from inception.

Finite revelations on a wisp of a whim. We can begin to end looking at any time.

Together we rub our eyes to make sure we're not dreaming.
Deliriously happy.

Time doesn't touch this sensational rationale. We like to connect.
Often times something seems to spoil the effect.

Playing and staying, joined at the hip. Shining privately
exchanged intent glances.
The heightened thump, tingling all the way into the cerebral
cortex.

It's Nice in the Shade

Not brash, not brazen, notoriously outspoken.

Absolute witticisms. Masterful delights.

The conversation just keeps becoming more interesting.

Get your groove on. Literally glittery. Smooth, supple, and serene.

The back seat is so spacious. No need for ostentatious rumours.

Silence is not dead. Stunned to glance past that mirror.

Grace is attainable. What's the difference between the garbage, and the truly useful information?

Innocuous preventative measures to choke on your tears.

Breathe it in, and slowly breathe it out. Take off the competitive edge.

Squatters trying to occupy paradise. The applause was earned, we are worthy.

Keep the focus on what is in front. Worry is a weakened state. Strength is one that is heightened.

Digging the graves of vengeance. Storytelling is how we learn.

Self-same blame is chased until we meet a dead end.

It's not simply rough around the edges, it's all the way buried deep.

A sun soaked dance, drenched with blessings. Sashay through the crowded room with panache.

Never to be beaten for one other's gain. Sadness comes from the bonds of defeat.

Now is everywhere that there is to be. There's never good enough reason to shut it down.

Take your time to think about it, let it evolve.

Reverberation

It was an exertion way down to the ovens of Dante and Virgil's vile landscapes.

Settlements on the outside fringes. The angels lifted their feet. The partnerships thrive on intersections.

Believe in the absence of fear, actualize that sage advice.

Conquer every realistic skill. Skip those indelicate hesitations.

Animate those grim grievances.
Agree to hold supporters who are dear. There are some jagged rocks just below the surface.

There may be ceaseless outcomes.

The fingertips do all of the work. Resurrect fond held hopes, and desires.
Glide gracefully along the ice.

Treat kindly wishes with prudent trial, and error.

Favourable reviews are elemental. Not to be outdone, is to be outrageously smug.
It is alright to be creative.

How much it lost its initial appeal, is to be duly noted.
The poison absorbed it all, it could not be diluted.

The renewed sense of pride was deplorable. Wipe that disgusting grin off your face.

Surreptitiously wrap your arms around me, out in the open.
The strike was made with meticulous precision.

O Hockey, O Hockey!

Where have you gone my trustworthy friend?

You've given yourself to a professional liar, making up slick contracts.

Trading away the goalies who were given over to one team for their lifetime.

It used to be all about the grit, the glory of putting that puck in the net. O with great sacrifice did our skillful soldiers battle on.

Now it is about trades, about high scoring, about what controversial back biting that goes perpetually on.

How about that shut-out when clearly the team sport is not determined in solo recognition.

You split up McLean and Cherry for whose voices of seasoned experience make all of us revere the game.

It was not just a sport you see it was an institution not unlike the CBC!

It has been so long since a Canadian team has hoisted the cup.

We long for the days gone by.

One thing that can not be changed is that inexplicable feeling we have when collectively we come together to rant and rave about our beloved players, our masterful sport, and our unique perceptions of those hockey dreams!

www.ingramcontent.com/pod-product-compliance
Lightning Source LLC
Chambersburg PA
CBHW031050180526
45163CB00002BA/773